VICTORY
1945

IN PHOTOGRAPHS

VICTORY
1945
IN PHOTOGRAPHS

Quotations

p. 6 Act of Military Surrender (Reims) 1944, Records of the U.S. Joint Chiefs of Staff, Record Group 218, National Archives.

p. 30 Harry Mount, 'The Queen's Big Night Out: what really happened', *The Telegraph*, 25 April 2015.

p. 78 'Victory Celebrations', *LIFE*, 27 August 1945.

p. 94 HC Deb 28 October 1943 vol 393 cc403-73.

p. 120 'We face the future with stern resolve', BBC News, 5 May 2005.

All images are provided by Mirrorpix and are available to purchase from www.vintagephotosonline.co.uk

First published 2019

97 St George's Place, Cheltenham,
Gloucestershire GL50 3QB
www.thehistorypress.co.uk

British Library Cataloguing in Publication Data.
A catalogue record for this book is available from the British Library.

ISBN 978 0 7509 9332 6

Typesetting and origination by The History Press
Printed in Turkey by Imak

CONTENTS

THE END OF HOSTILITIES

We the undersigned, acting by authority of the German High Command, hereby surrender unconditionally ...

German Instrument of Surrender

When the First World War ended, the prevailing response was 'never again'. But it would happen again, a mere twenty years later – just enough time for the babies born out of victory and celebration to find themselves on the front lines.

The beginning of the end happened with the Normandy landings in June 1944, which started the mass take-back of Nazi-occupied territories. It would take a year, but the Allies would push through Europe to Germany and the real prize – Berlin. The Soviets surrounded the German capital city by the end of April: faced with the anger of his former friends, Adolf Hitler committed suicide on the 30th. Days later, the Nazis surrendered.

The Second World War lasted for six years and one day and brought with it an array of devastation that the world had never seen before. Those were six long years of death and destruction: countries razed to the ground; millions dead, both civilians and soldiers; and, as word spread of concentration camps and atomic bombs, a new knowledge of the horrors that humans could inflict on each other. It was a war that left great scars on the psyche of the whole world.

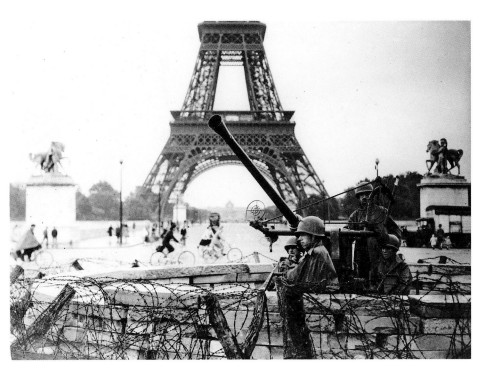

⋏ May 1945: A US Army anti-aircraft gun beside the Eiffel Tower after the Liberation of Paris.

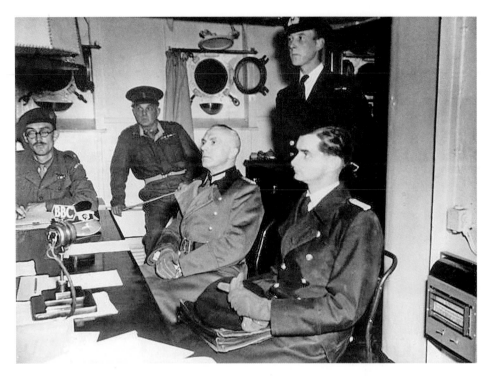

▲ **May 1945:** Major General Heine and Lieutenant Armin Zimmermann prepare to sign the instrument of surrender aboard the British destroyer *Bulldog*, 4 miles off the coast of Guernsey, signalling the liberation of the Channel Islands.

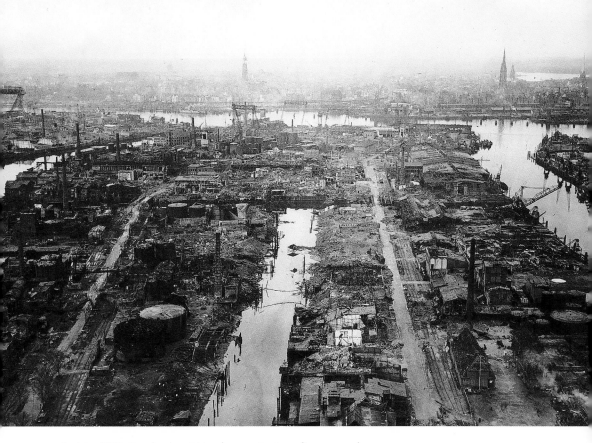

▲ **May 1945:** Bombed-out Hamburg, minutes after surrender.

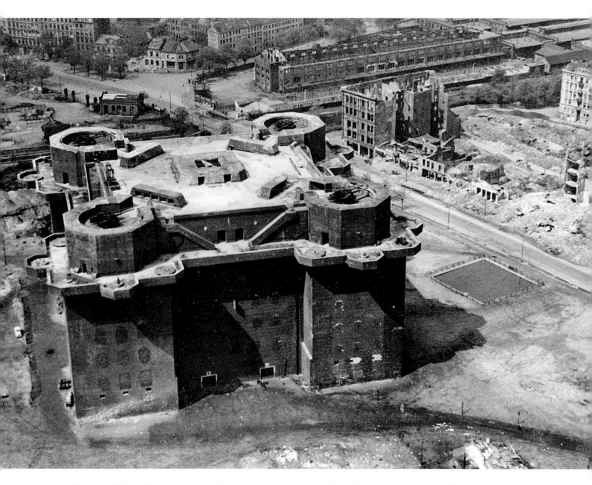

▲ **May 1945:** The devastated German capital city of Berlin three minutes after the German surrender. Huge concrete 'ack-ack' (anti-aircraft) flak tower fortresses stand amid the ruined dock and railway areas.

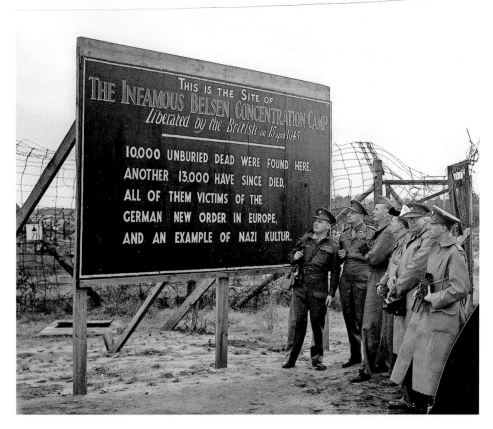

▲ **September 1945:** British soldiers at the site of Bergen-Belsen concentration camp. Bergen-Belsen in Germany was one of the more horrific of Hitler's camps, where prisoners were gassed, shot or otherwise brutalised by the guards. Officially used as a holding centre from April 1943 until April 1945, the British liberated it and the Kommandant, Josef Kramer, was arrested.

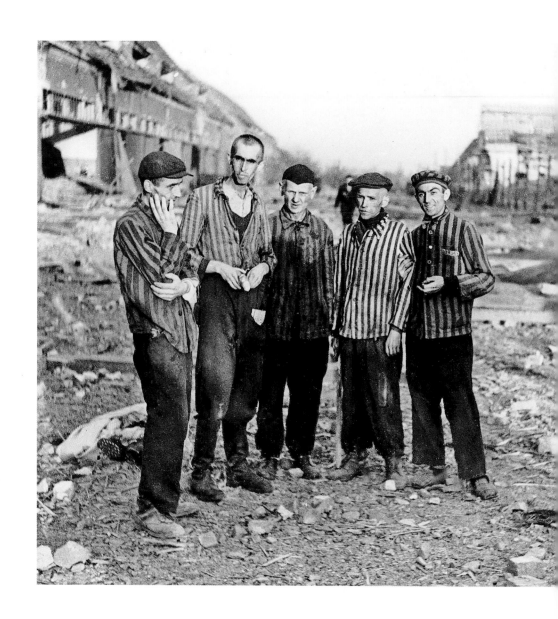

◄ **April 1945:** French political prisoners liberated by US First Army troops.

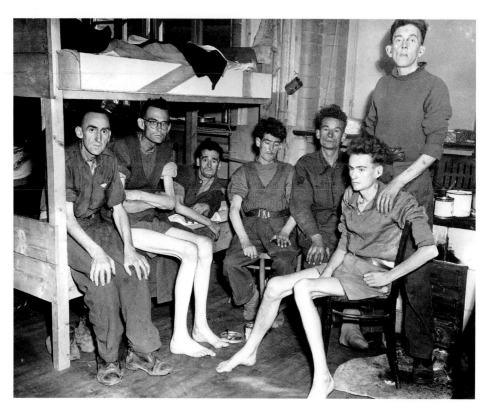

▲ **April 1945:** British prisoners of war liberated by the British 2nd Division after five years in captivity.

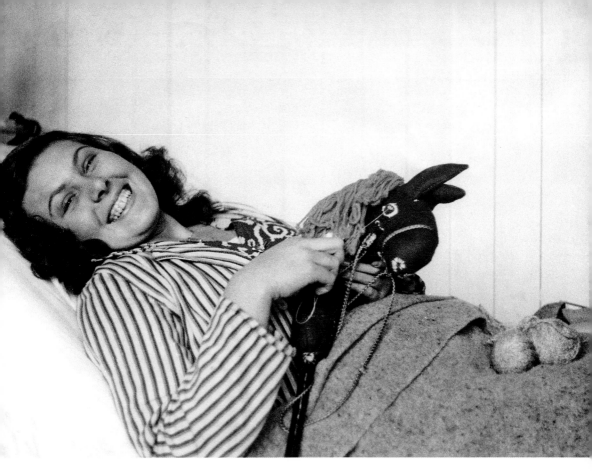

▲ **November 1945:** Teenager Susi Kstona, who was brought to Belsen from Poland by the Nazis in 1943, recovers in the Glyn Hughes hospital in Lüneberg following the liberation of the camp by Allied forces. She is holding a toy horse that she made from old German uniforms and bits of wood.

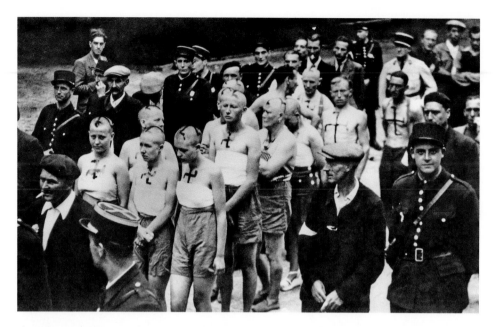

▲ **February 1945:** French men and women, accused of collaborating with the Germans during the occupation, are marched through the streets of Paris in the early days of the liberation. They have had their heads shaven and are partially stripped – but many had only committed 'crimes' such as talking to a German outside their shop.

∧ **March 1945:** German civilians emerge from their homes as the 35th US Infantry Division occupy Lindfort.

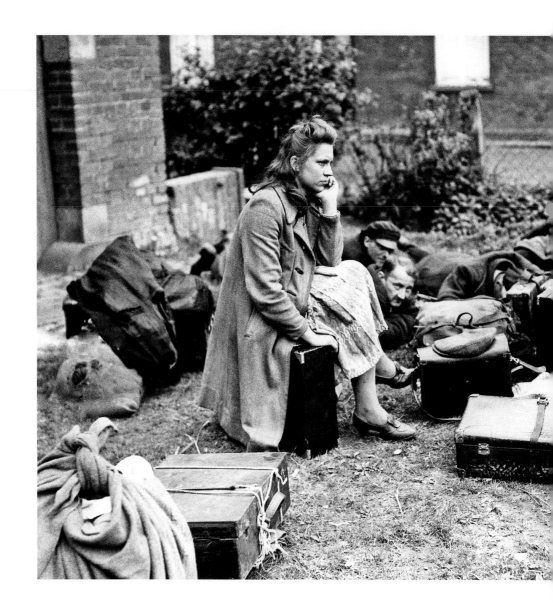

◄ **April 1945:** Allied civilian prisoners after being released from a German prison camp.

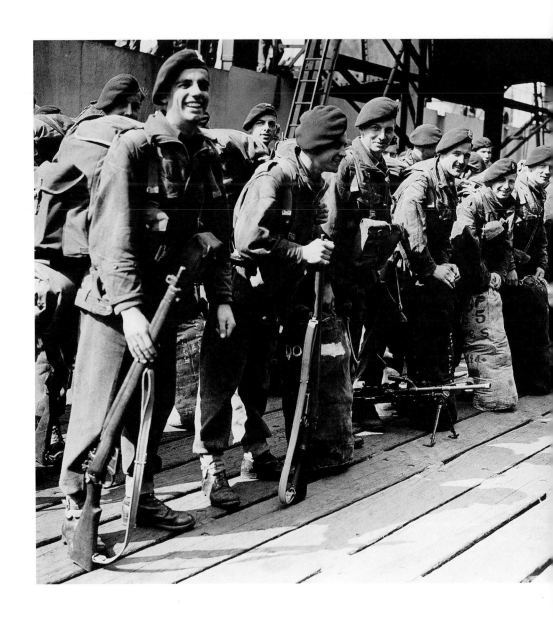

◄ **June 1945:** The scene at Tilbury as the 3rd Commando Royal Marines return to England after their second visit to the Western Front.

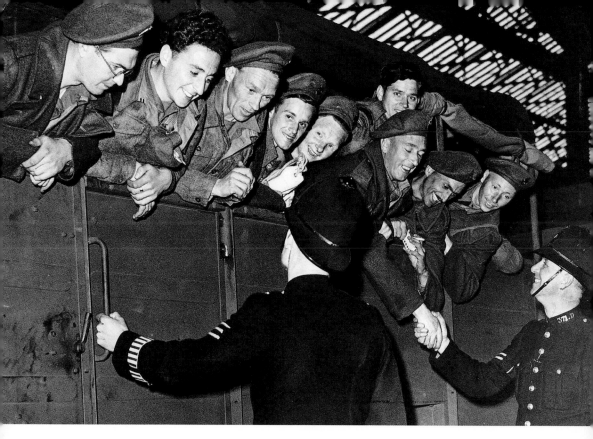

▲ **April 1945:** British former prisoners being greeted by policemen after arriving at Marylebone station.

▼ April 1945: More than 300 US prisoners of war after being freed by an American armoured division.

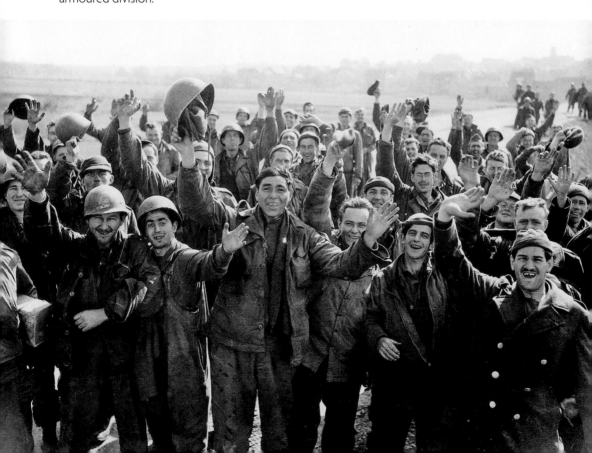

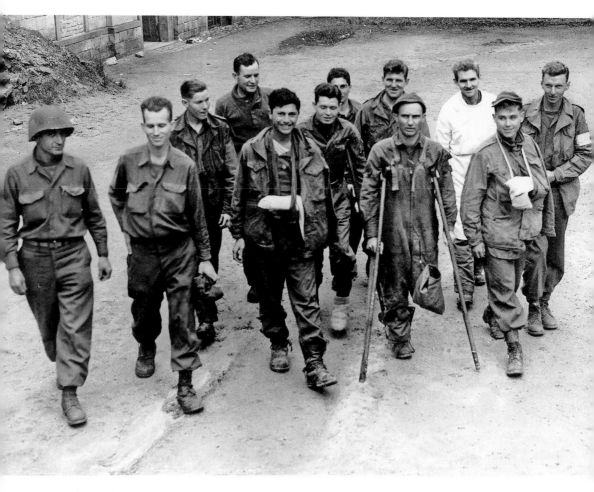

▲ **April 1945:** American prisoners and some RAF men after being released from the hospital camp in the German town of Heppenheim.

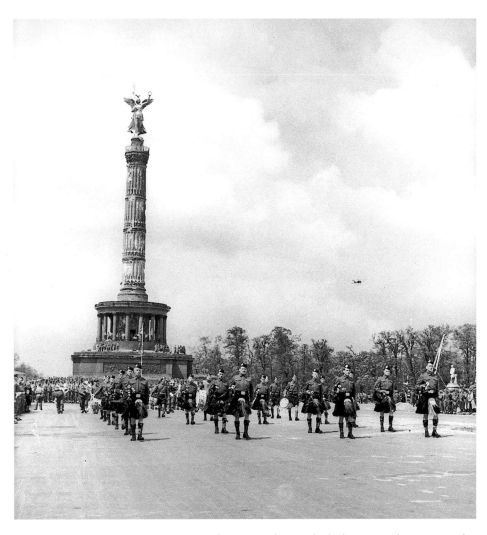

▲ July 1945: A parade at the Victory Column in Berlin, at which the Union Flag was raised after the end of war in Europe.

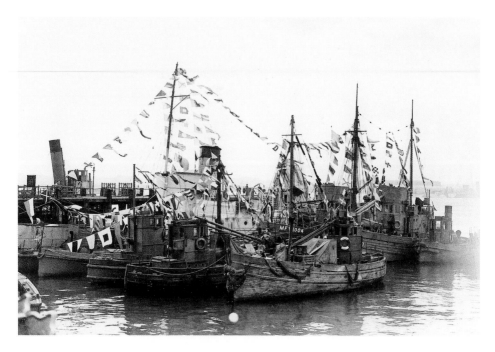

▲ **May 1945:** Boats in Southampton Docks decorated with flags after peace had been declared.

➤ **June 1945:** A discharged soldier leaves a store wearing his demob suit.

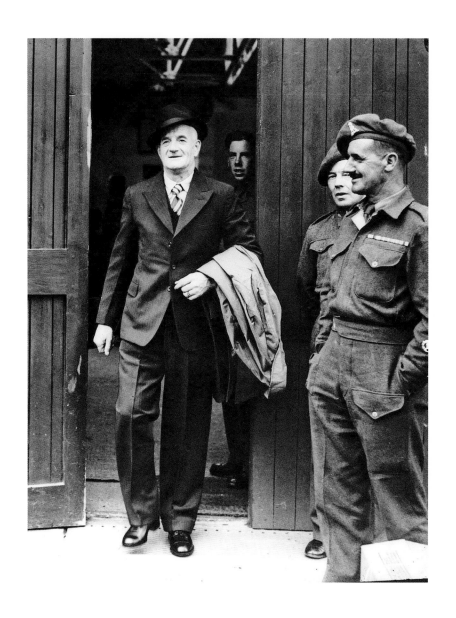

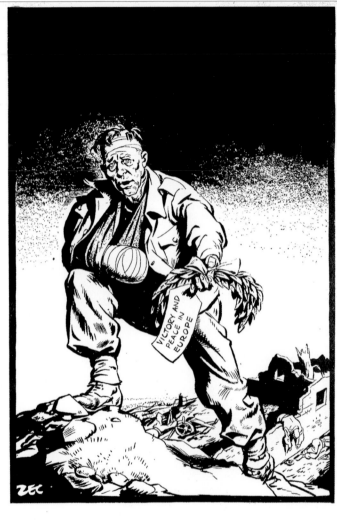

"Here you are! Don't lose it again!"

◄ May 1945: 'Here You Are! Don't Lose It Again!', a VE Day cartoon by Philip Zec for the *Daily Mirror*. This cartoon would be reprinted on the front page of the *Mirror* in the July General Election, urging readers to vote Labour. Labour won in a landslide.

 Daily *and Mail* **Record**

EST. 1847—No. 30,668 1d TUESDAY, MAY 8, 1945 A KEMSLEY NEWSPAPER

"BLACK & WHITE"
It's the Scotch
MAXIMUM PRICES

Spring for—
WILLIAM YOUNGERS BEER

SURRENDER TERMS SIGNED

WAR NOW OVER—THIS IS VE-DAY

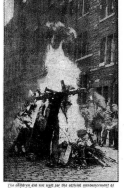

The children did not wait for the official announcement of the end of the war. They just went to it—and set their bonfires alight. Celebrations like this were going on in many parts of Glasgow and Edinburgh last night.

THE war is over. Unconditional surrender has been received from Germany by Britain, America and Russia.

But the official announcement from the lips of Mr. Churchill will not come until this afternoon, when the Prime Minister will broadcast at three o'clock.

H.M. the King will broadcast to the peoples of the British Empire and Commonwealth to-night at 9 o'clock. Parliament will meet at the usual time to-day.

In view of this fact, to-day will be treated as Victory in Europe Day and will be regarded as a holiday. To-morrow, Wednesday, May 9, will also be a holiday.

Ed Murrow, of the Columbia Broadcasting System, in a broadcast from London last night, said that Mr. Churchill and President Truman were ready to make an official surrender proclamation at any moment, but Marshal Stalin declared that he was not ready and it was agreed to postpone the announcement.

WAR CHIEFS ON RADIO

Fifteen people will take part in "Tribute to the King," the broadcast which will precede the King's broadcast to-night.

They include representatives of the Dominions and Colonies, the three fighting Services, the Merchant Navy, the Police and Civil Defence forces, a nurse and a London housewife.

It is hoped that the voices of the following will be heard in "Victory Report," the broadcast which will follow the news after the King's speech:—Eisenhower, Montgomery, Alexander, Tedder, Bradley, Admiral Tovey and Mountbatten.

SURPRISE DELAY

Explanations of the surprising delay in announcing VE-Day, in spite of the complete capitulation by the Germans, lies in the importance which is attached to synchronising the news in London, Washington and Moscow.

Telephone calls went on all through the day between Mr. Churchill, President Truman and Marshal Stalin. Differing views were apparently held on when the public should be told.

Continued on Back Page, Col. 2

BBC

Mrs. Henderson, of Carshalton, who will introduce the King on the radio when he makes his speech to-night.

 FRY'S COCOA *and all's well*

Clyde Ships V-Daft; Sirens, Rockets, Flares

AT midnight last night hundreds of ships—warships, merchant ships, tugs, steamers, motorboats and anyone possessing a horn, a hooter or an old A.R.P. rattle opened up in the Firth of Clyde to create the most tremendous victory din likely to be heard in any part of the country.

For miles around and far inland the noise was heard and people on the coast, excited by the din and the spirit behind it, suddenly defied the coast blackout ban and allowed their lights to blaze out into the streets.

The Tail of the Bank was ablaze with light from multi-coloured flares, while rockets discharged from ships gave a display reminiscent of peace-time illuminations.

Church bells rose from the Cowal Shore were heard ringing.

GLASGOW GAIETY

Glasgow became a city of revelry last night. Crowds packed the main streets, dancing and singing to the accompaniment of guitars, mouth organs, and other instruments.

A British and an American soldier led community singing in George Square, where many people added to the gaiety by wearing paper hats.

The night sky all over the city was aglow with the light from hundreds of bonfires.

Late city transport could not cope with the homeward-bound crowds.

"Blazing Bonfires Anticipate VE-Day."—Page 3

THE FAMILY FOOD DRINK WITH THE REAL CHOCOLATE FLAVOUR

½ QTR LB ● ½ HALF LB

48 BRITISH SHIPS OFF OSLO

NAZI CHIEF ORDERS 'NORWAY SURRENDER'

"GERMAN soldiers in Norway, the German Foreign Minister, Count von Schwerin-Krosigk, has ordered the unconditional surrender of all German forces," said General Boehme, commander of German forces in Norway, over Oslo radio last night.

Allied naval units are reported to have arrived in Oslo Fjord. It is believed they will form the first nucleus of the British Mission there, says a message from inside Norway.

Although the Norway surrender has not yet been confirmed from Allied official

Continued on Back Page, Col. 1

BRESLAU FALLS.

U.S. 7 Miles From Prague

THE Patriot Prague radio at 11.36 last night reported that advancing U.S. tank units, presumably General Patton's, had just passed the town of Reporyje, about seven miles south of Prague.

It was officially announced last night that hostilities have ceased on the French 1st Army front, said Paris radio.

Russians Take Breslau

Stalin in an Order of the Day last night announced: "Forces of the First Ukrainian Command after a prolonged siege to-day, May 7, completely captured the town and fortress of Breslau.

"Up to 7 o'clock to-night had taken prisoner over 40,000 Germans in Breslau."

NEW WORK PLAN BEGINS

THE Government plan for the re-allocation of man-power will come into force to-day.

Members of the three services will not begin to be demobilised until six weeks after VE-Day. Then the first out will be those in Class A, the Class B Top 11 Groups, and the Class B, Top 12 Groups.

Men in industry aged 18 to 27 too needed in war factories are to be called up for military service.

Women in 'industry—married or single—will be allowed to leave their jobs, providing they have household responsibilities or wish to join their husbands on release from the Forces.

Where a factory closes altogether, men not in the 18 to 27 age groups will be transferred to other employment in the following order of priority:

Those needed for priority vacancies, including vacancies for skilled and experienced workers who are needed for re-establishing important industries and services; those who want to return home after

working away for over a year but less than three years.

The major objective, the Government states, will be to return as many persons as possible to their homes, and those released will be sent to work as near to their home towns as possible.

The Essential Works Order will be lifted as soon as circumstances permit and replaced with the Control of Employment Order for women between 18 and 60 years of age and the Control of Engagement Order for men aged 18 to 50.

Why VE-Holiday Was Changed

THE decision that to-day *(Tuesday)* should be regarded as a whole holiday *is a departure from the original plan, under which VE-Day was to have been a holiday only from the time an announcement was made.*

This change was occasioned by the feeling in official circles that news of the complete surrender had spread throughout the country and would be pointless to continue as though the Premier's announcement of final victory in Europe would be a surprise.

No 'Daily Record' on Thursday

The "Daily Record" will be published to-morrow *(Wednesday)* but not on Thursday. Publication will be resumed on Friday.

The "Evening News" comes out as usual to-day, but publication is suspended on Wednesday, with resumed publication on Thursday.

CELEBRATION

VE DAY

I remember lines of unknown people linking arms and walking down Whitehall, all of us just swept along on a tide of happiness and relief.

Elizabeth II

8 May 1945: At 3 p.m., Winston Churchill declared that the war in Europe had come to a close: the Germans had surrendered and Berlin had fallen. It was finally over.

The war itself would rage for another ninety-nine days, but for the people of Britain, who had lived almost six years under the shadow of the Luftwaffe, there was plenty to celebrate – and celebrate they did. Anticipating high demand, Churchill made sure to check that there would be enough beer to last the night. Red, white and blue bunting was taken off of the list of rationed wares. People danced in the streets with strangers and climbed lampposts in jubilation.

Even the royal family got in on the fun – the king and queen sedately celebrated from Buckingham Palace, whilst 19-year-old Princess Elizabeth and 15-year-old Princess Margaret snuck out to party amongst the crowds of London.

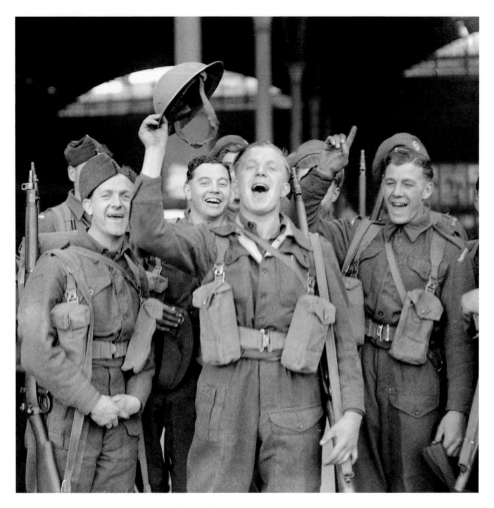

⋀ Soldiers celebrating at a London railway station.

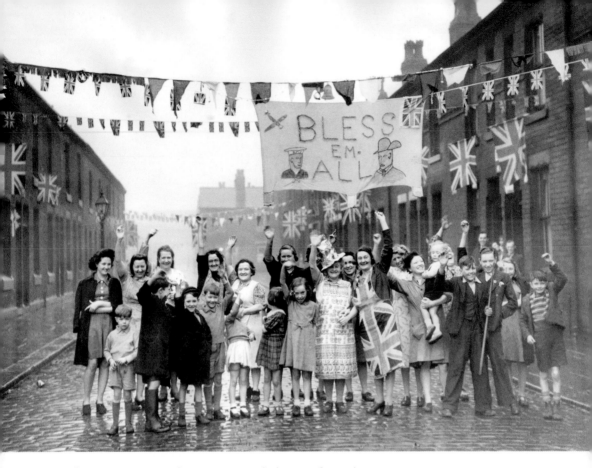

▲ A street party in the Newton Heath district of Manchester.

▼ Workers celebrate in Manchester.

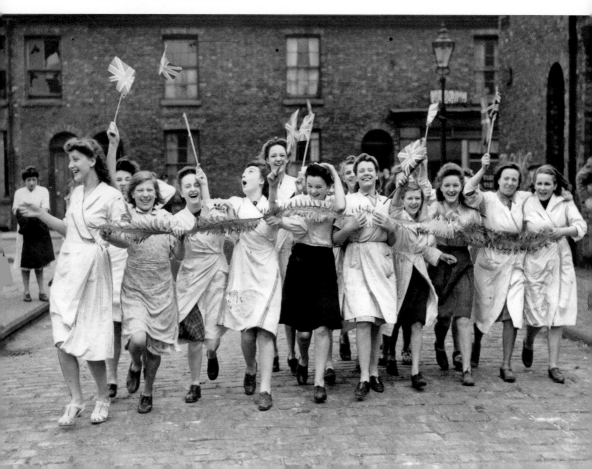

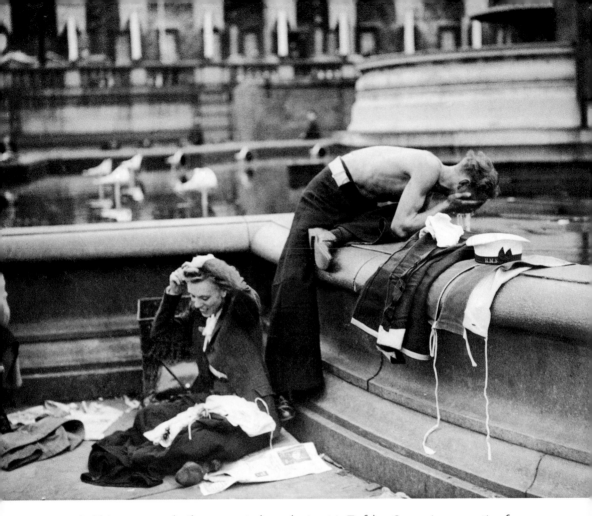

▲ This woman and sailor appear to have slept out in Trafalgar Square in preparation for the VE Day celebrations. While she prepares her hair, he washes in the fountain, his uniform and flag crisply folded at his side.

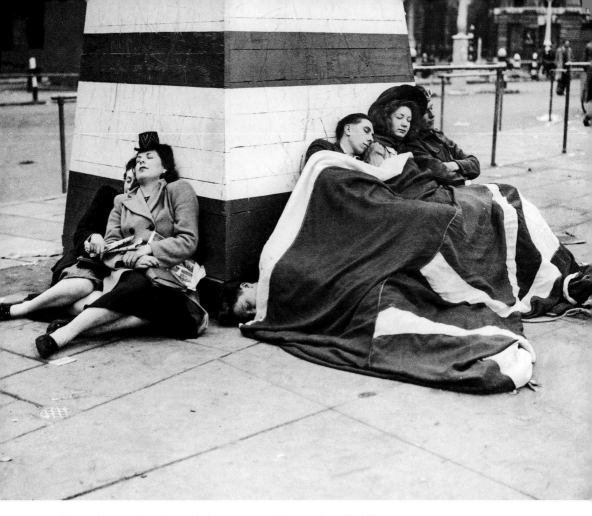

▲ Londoners sleep through the morning after a night of celebrations.

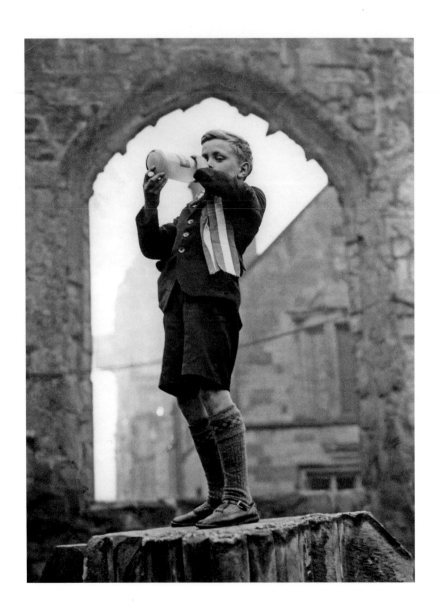

▲ With the approach of victory, Coventry prepares for peace celebrations, rushing to the store for flags and bunting.

◄ After the VE Day service in the bombed-out ruins of Coventry Cathedral, a youngster, bedecked with a rosette and banner, takes a drink form his bottle of cordial.

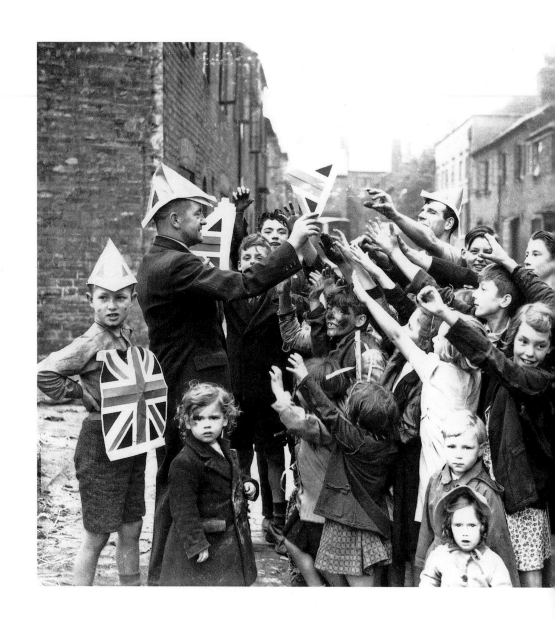

◄ Coventry children are given Union Flag paper hats and posters to help them celebrate.

> Coventry Cathedral was visited by thousands of people on VE Day, and services conducted by the Provost (the Very Rev. R.T. Howard) and the Bishop of Coventry (Dr Neville Gorton) did not end until after midnight. Four services had been arranged for the day, but the attending crowds were so large that supplementary services were held in the evening. The cathedral remained open all night.

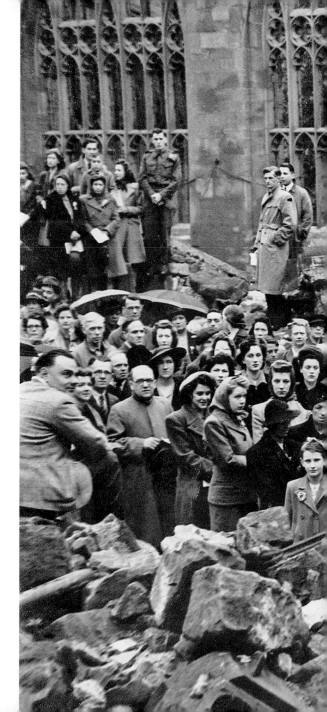

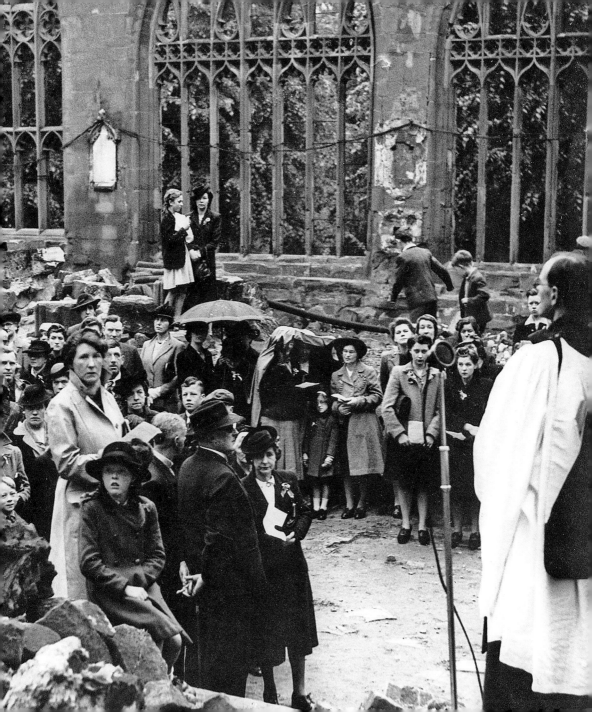

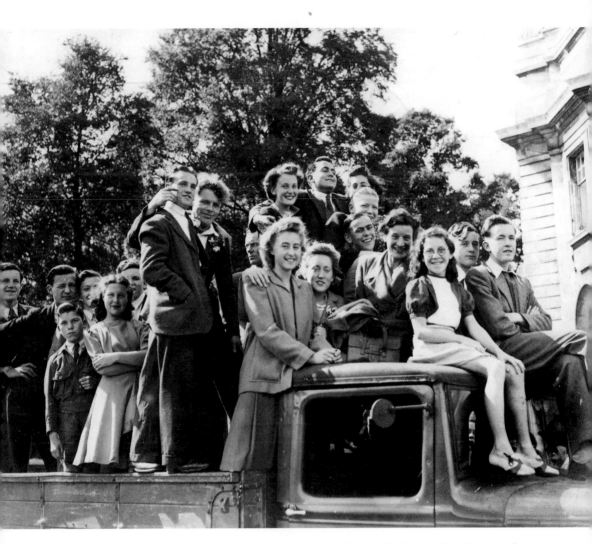

▲ These young people use a lorry as a vantage point during the Victory Day Service of Thanksgiving at Cathays Park, Cardiff.

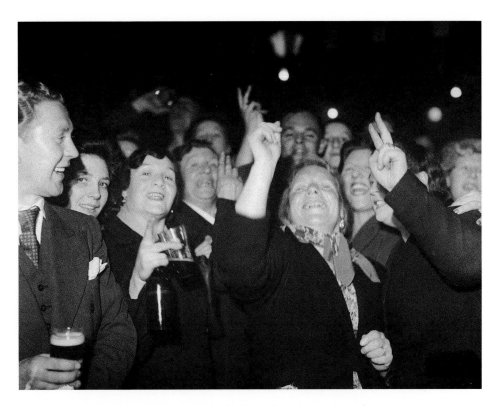

▲ Late-night revellers celebrate with a drink on the streets of London.

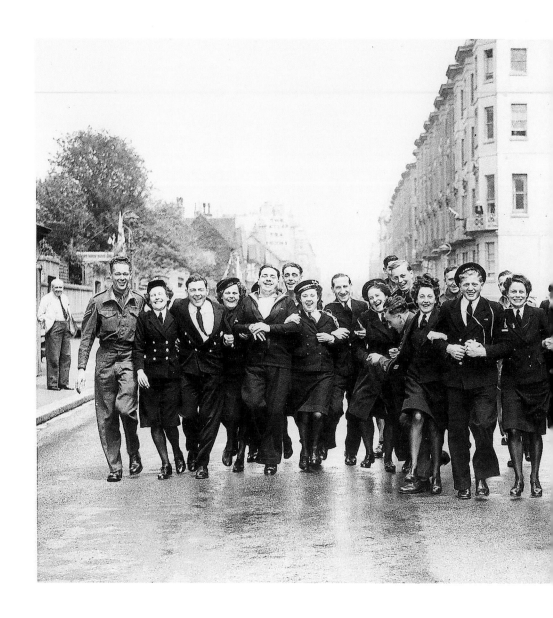

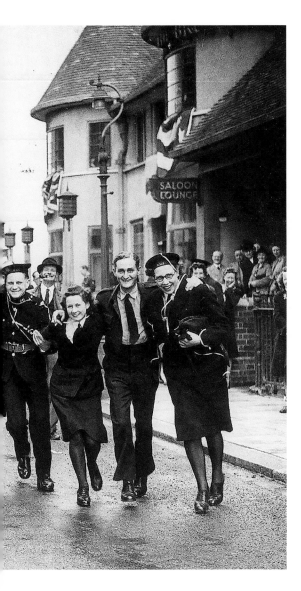

◄ Wrens, sailors and soldiers dance in the street in Brighton.

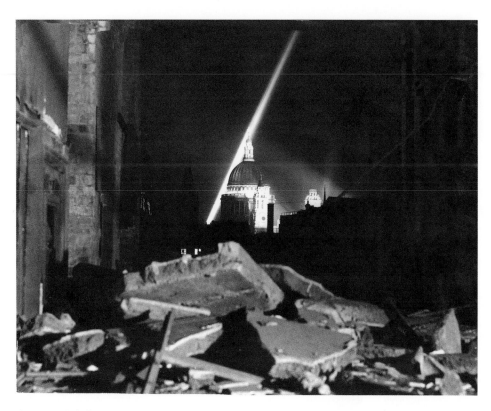

▲ St Paul's lights up.

❯ Celebrations in Trafalgar Square.

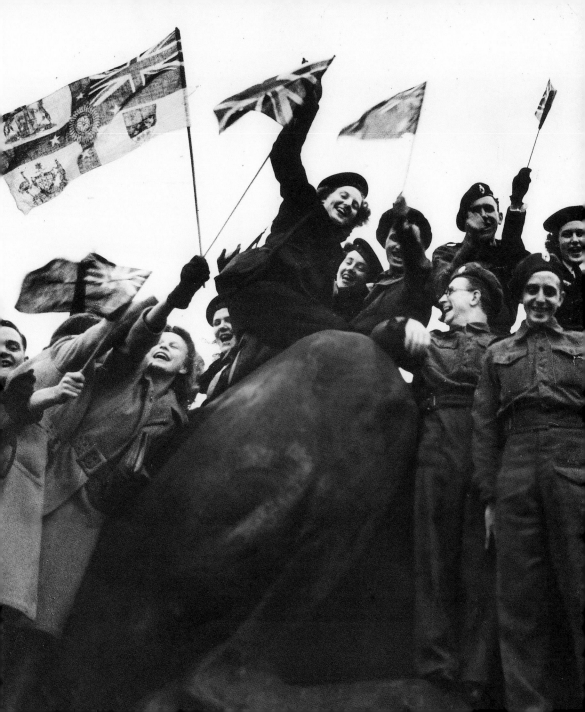

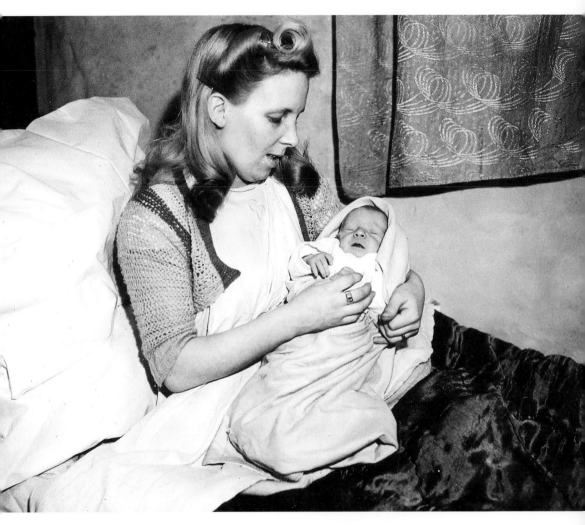

▲ Peace baby Victor Edward, born on VE Day and named for the occasion.

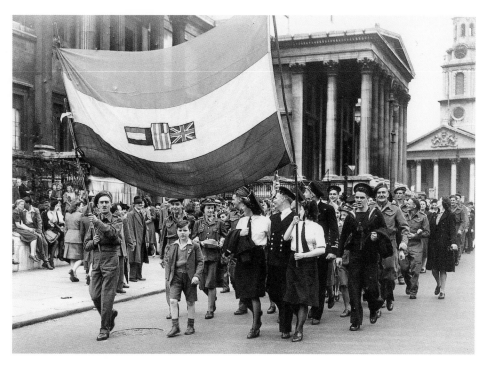

▲ Members of the Canadian, British, American and Norwegian forces march around Trafalgar Square.

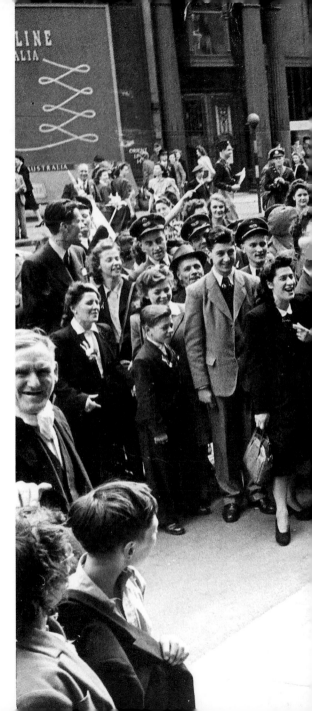

➤ A Canadian Seaforth Highlander dancing with an ATS girl in London.

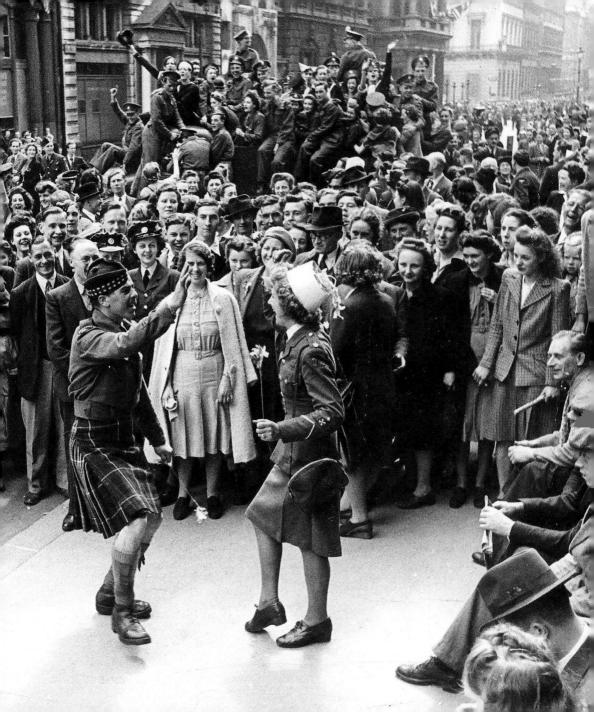

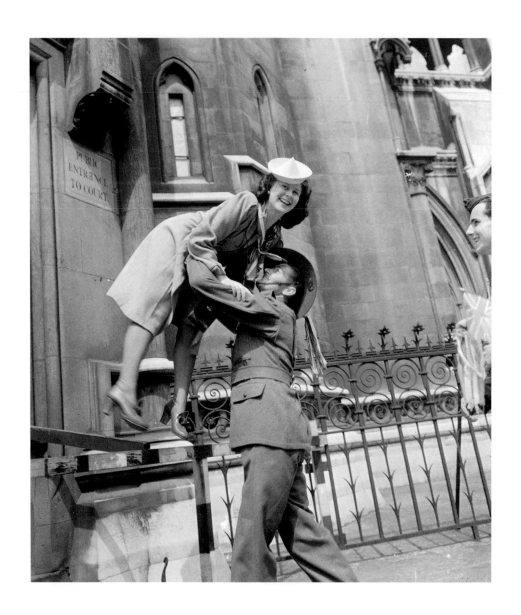

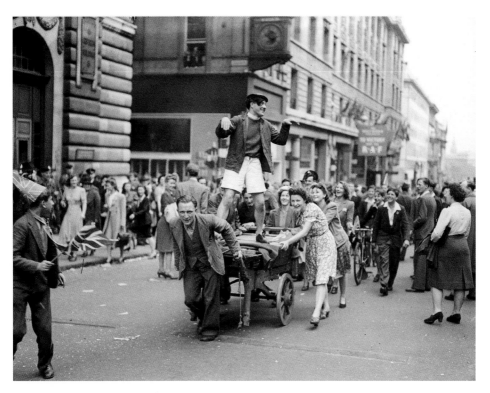

▲ Celebrations in London.

◀ An Australian soldier helping a woman down from her vantage point outside the law courts.

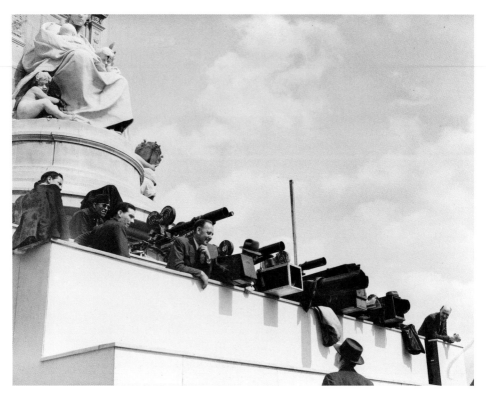

▲ Newsreel cameramen await the appearance of the king and queen on the balcony of Buckingham Palace after the Victory in Europe announcement.

➤ A German effigy is burnt during the celebrations.

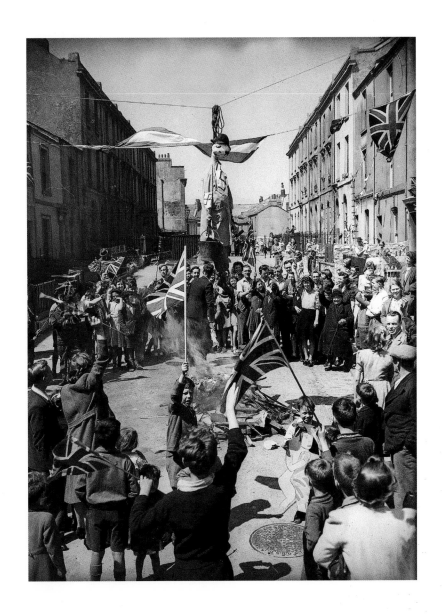

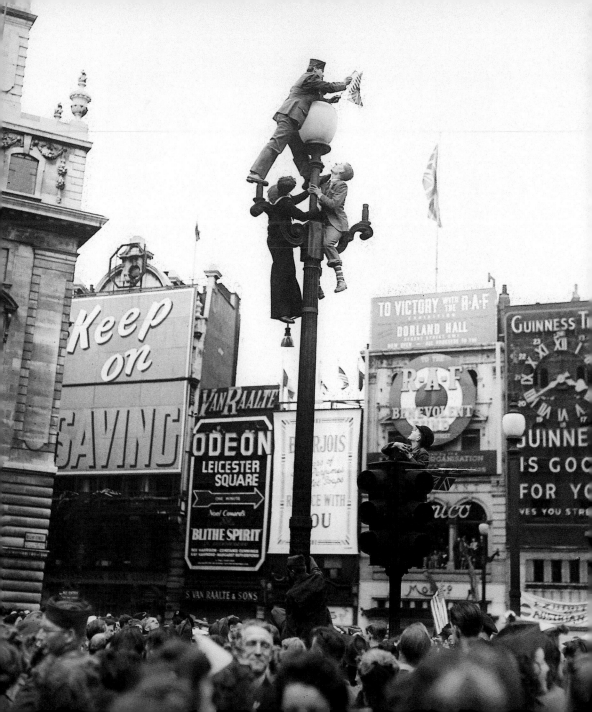

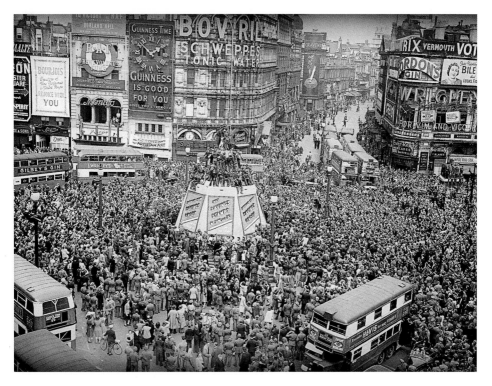

▲ Piccadilly Circus fills with crowds to mark the historic victory.

◄ High spirits in London.

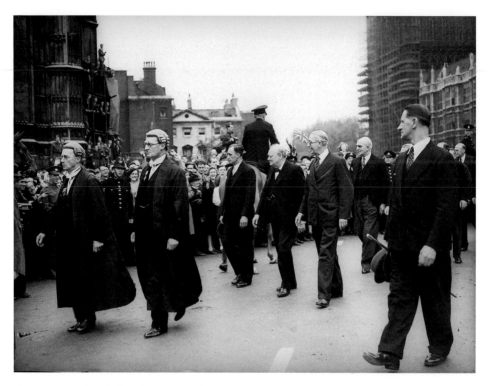

▲ Winston Churchill on his way to the Houses of Parliament for the victory service.

➤ A 'Victory Tea' in Newcastle.

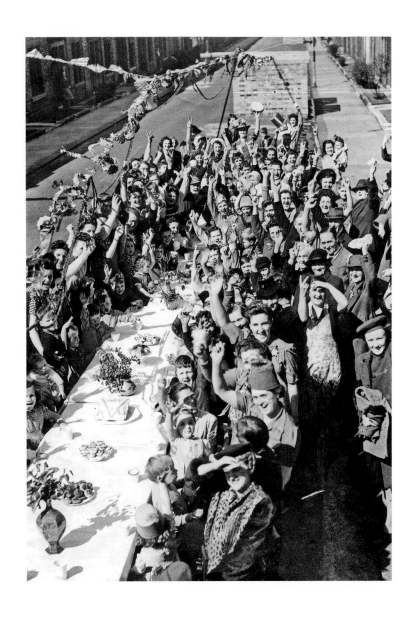

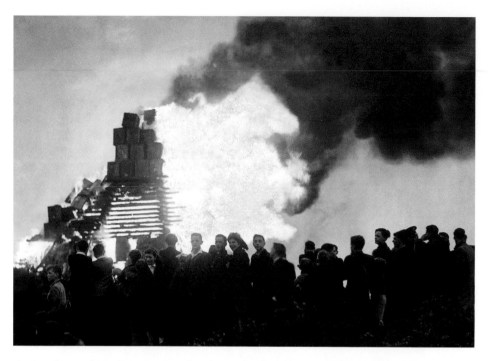

▲ Residents of Wrekenton, Gateshead, watch a bonfire to mark the occasion.

➤ The residents of Denmark Street, London, celebrating the announcement of victory by hanging out the washing, as mentioned in a popular song of the time, 'We're Going to Hang Out the Washing on the Siegfried Line'.

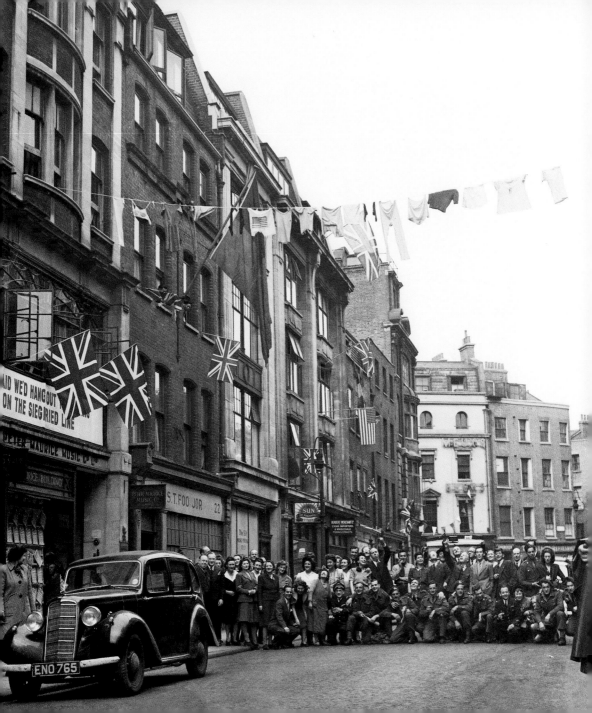

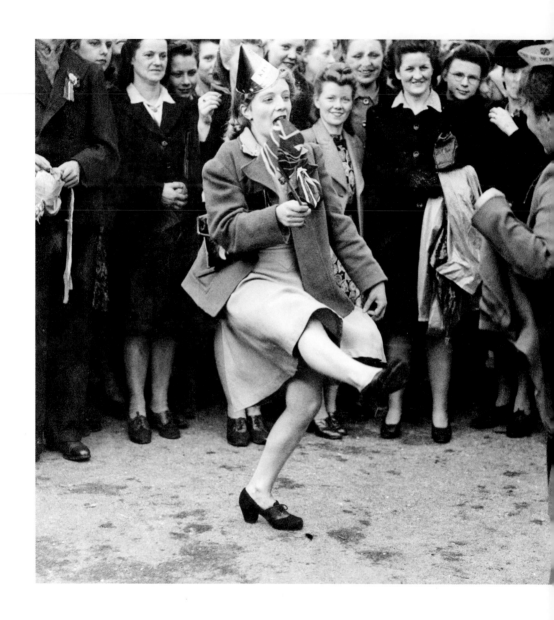

◄ People dancing in the street in Piccadilly Gardens, Manchester.

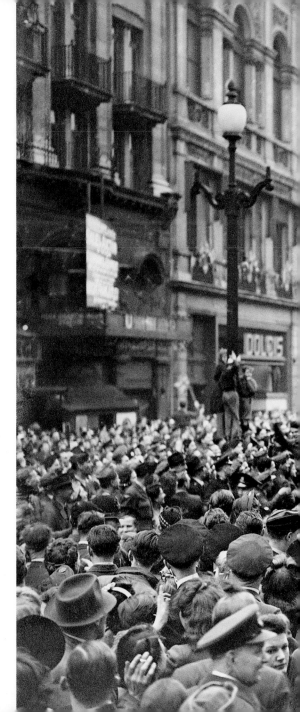

➤ Huge crowds gathered around
Piccadilly Circus ...

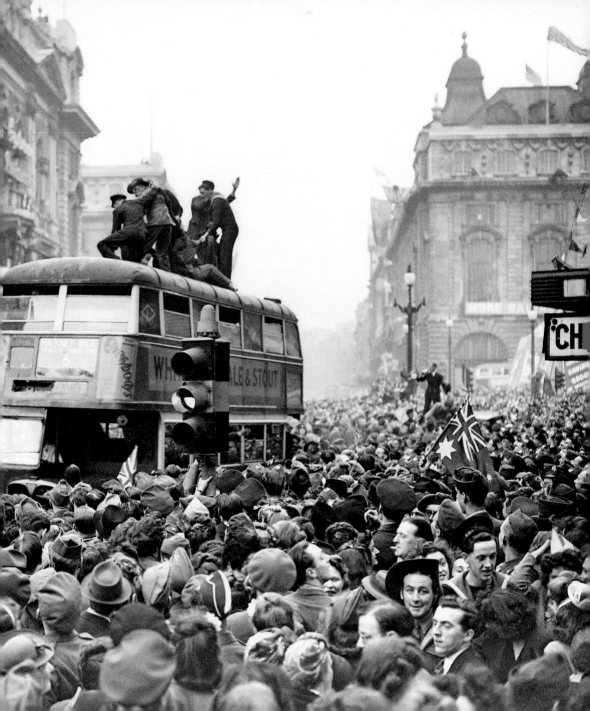

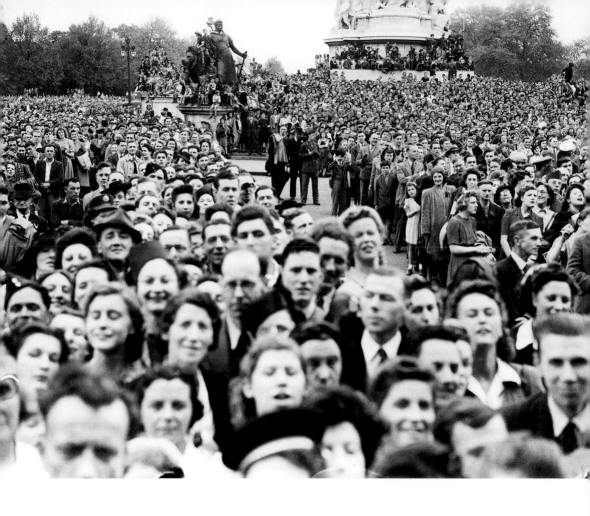

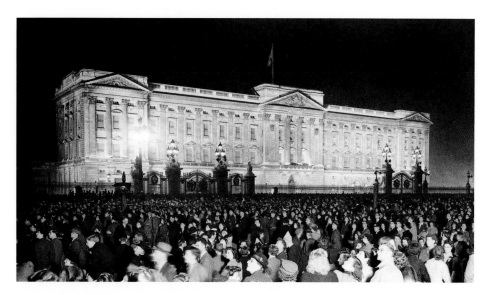

◀▲ ... and outside Buckingham Palace.

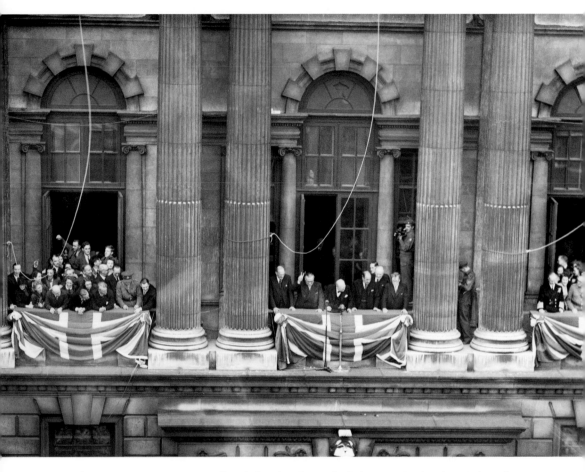

▲ Prime Minister Winston Churchill with MPs on the balcony at Buckingham Palace during the celebrations.

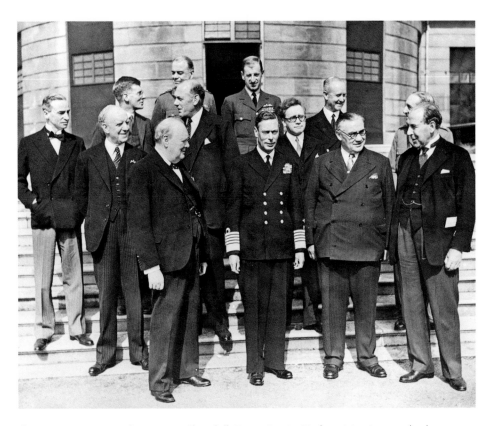

▲ King George VI with Winston Churchill, Ernest Bevin, Herbert Morrison and other members of Cabinet and Chiefs of Staff in the grounds of Buckingham Palace.

➤ King George VI
waves to the crowd
from the balcony at
Buckingham Palace,
accompanied by
Princess Elizabeth,
Queen Elizabeth and
Princess Margaret.

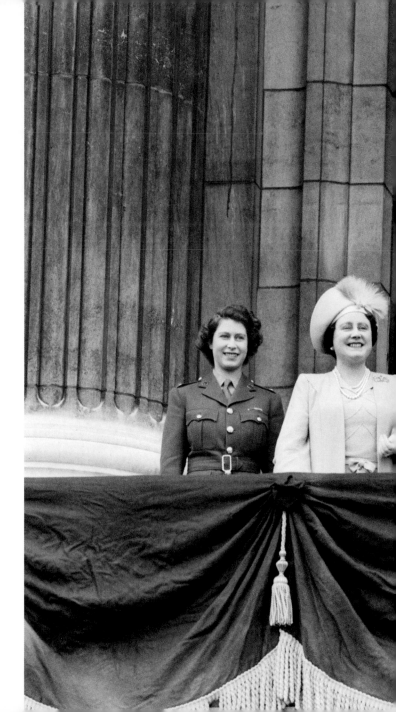

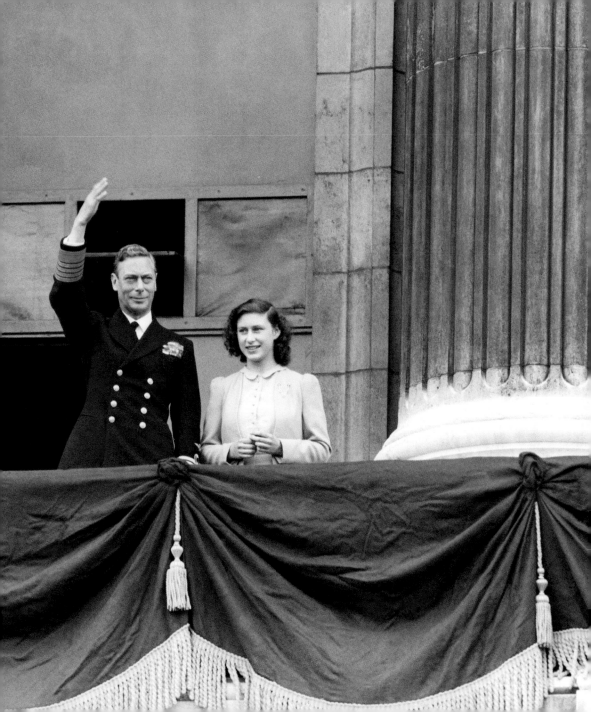

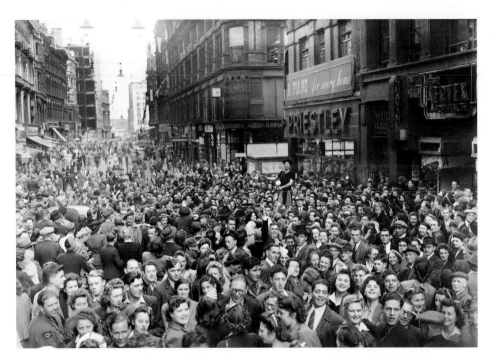

▲ Victory celebrations in central Birmingham.

➤ A bus conductor celebrating VE Day in Scotland.

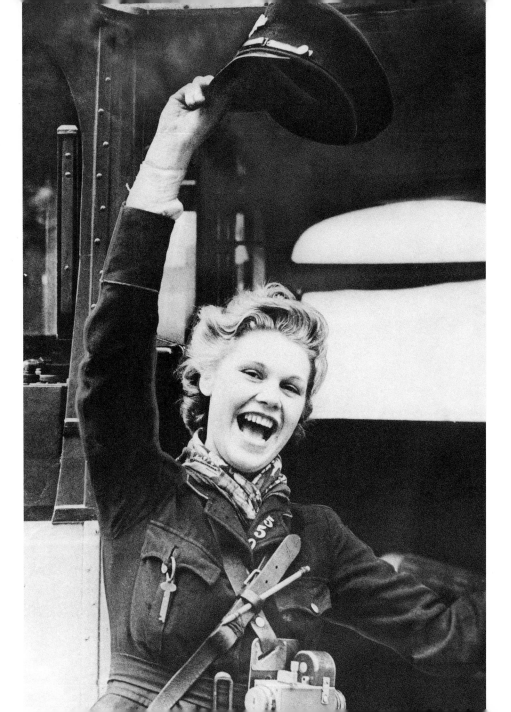

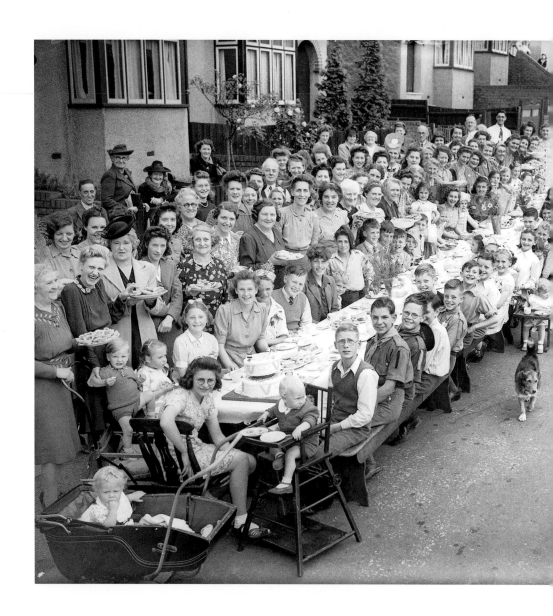

◀ A Bristol street party.

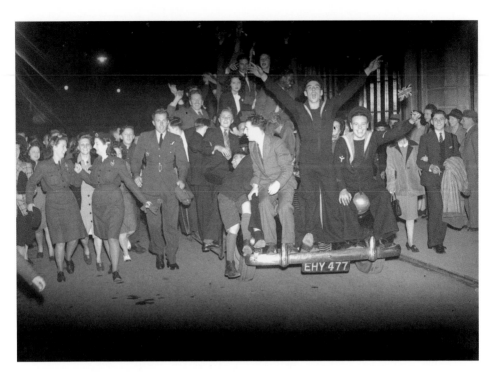

➤ Bristol crowds go wild.

➤ Jubilant nurses celebrate in Liverpool.

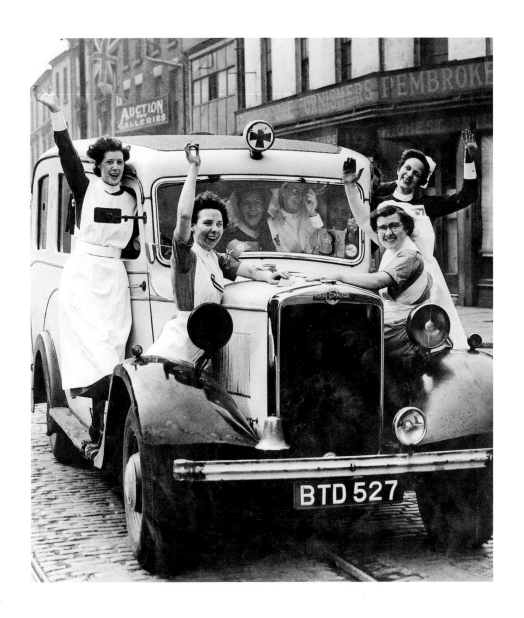

VJ DAY

It was as if joy had been rationed and saved up for the three years, eight months and seven days since [Pearl Harbor].

LIFE Magazine
27 August 1945

15 August 1945: Whilst 8 May marked the end of the war in Europe, it wasn't the end of the fighting. The Pacific War continued to rage, with the Imperial Japanese forces pitted against an Anglo-Chinese-American coalition. This war would be waged for months more – with horrifying consequences.

Ninety days after VE Day, the USSR invaded Manchukuo, an area of north-eastern China that had been occupied by the Japanese since 1931. The same day, America dropped an atomic bomb on the city of Nagasaki, the second nuclear attack on Japanese soil in three days. The next day, Japan began to make moves to surrender. The most devastating war in history was finally over. The world could finally begin to rebuild.

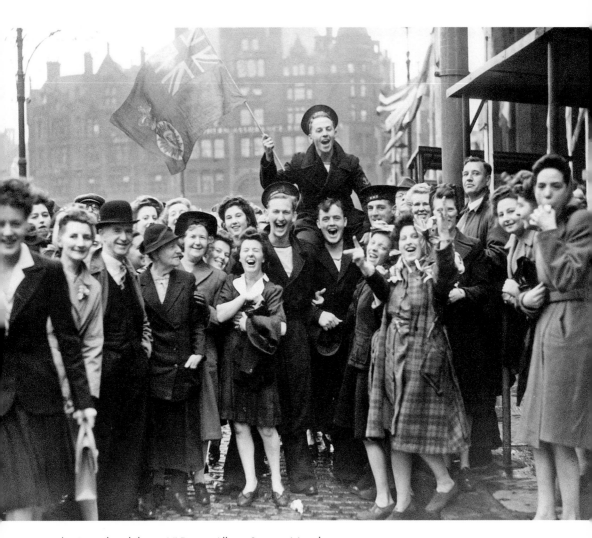

▲ Crowds celebrate VJ Day in Albert Square, Manchester.

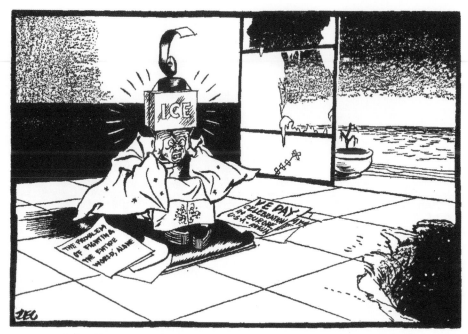

"No Hon. celebration—but what an Hon. headache!"

▲▶ More cartoons by Philip Zec for the *Daily Mirror*.

SET.

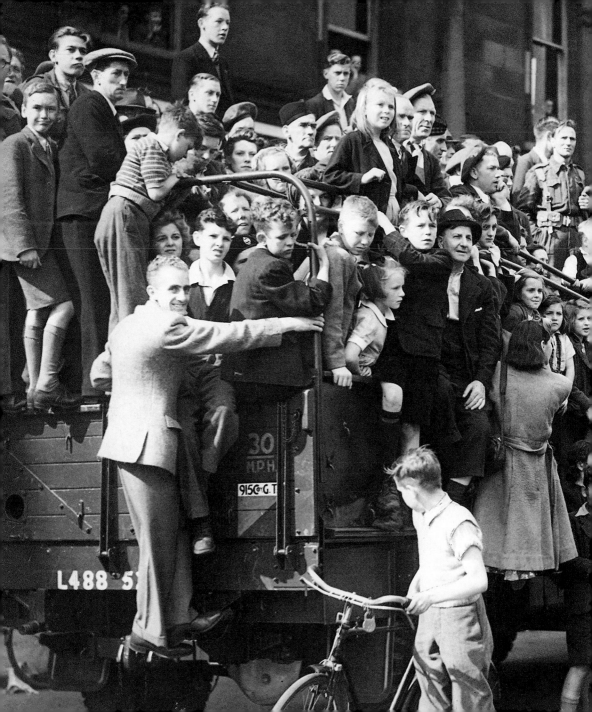

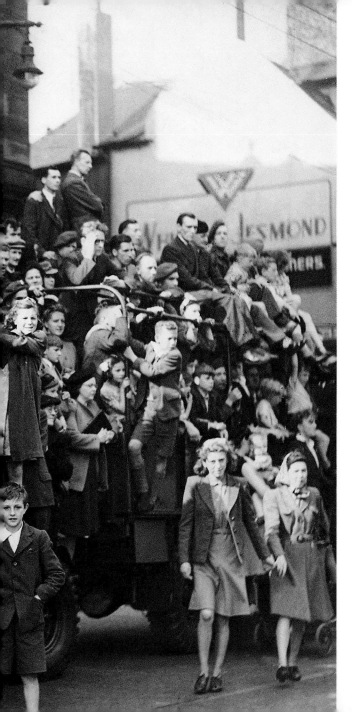

◀ People celebrate on the streets of Newcastle.

▼ Dancing in the streets of Edinburgh.

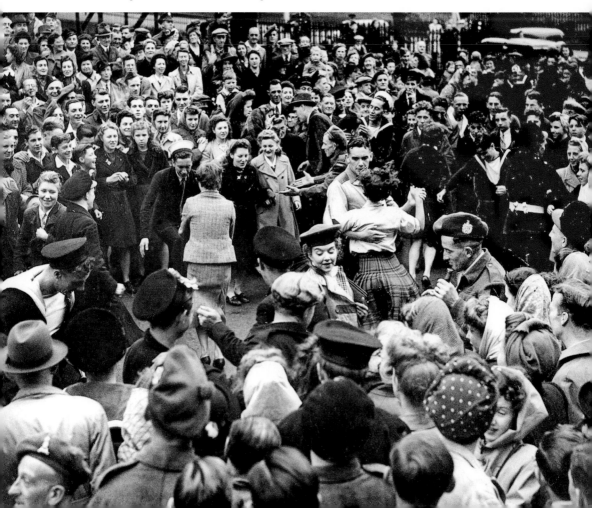

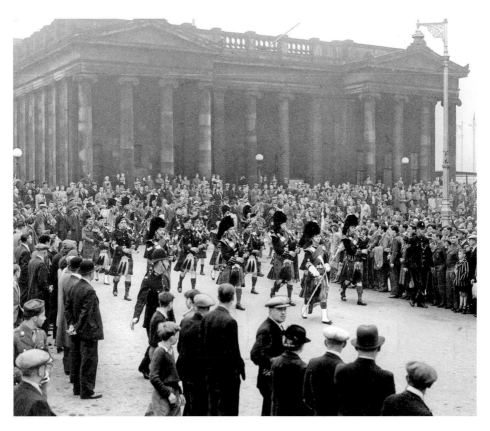

⌃ A pipe band marches down The Mound, Edinburgh, which is lined with crowds.

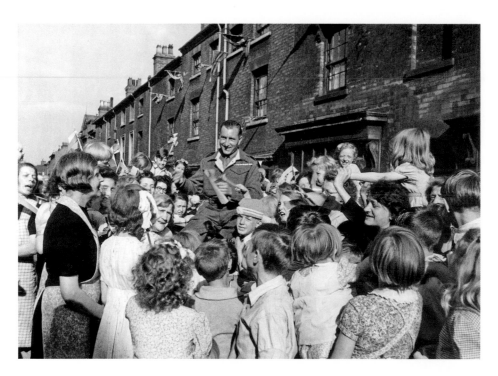

▲ 30-year-old Private Jim Kavangh of Edward Street, Birmingham, could not get home for VJ Day – so the children waited to celebrate until he returned.

➤ The *Daily Mirror* building decorated to celebrate.

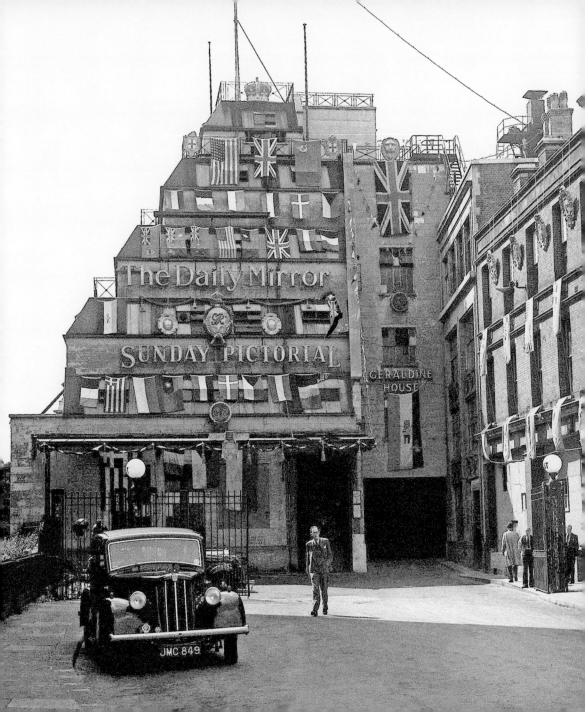

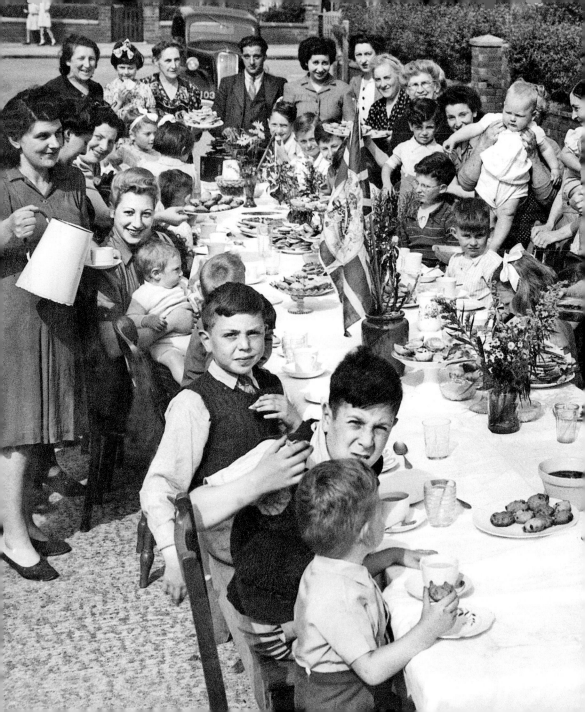

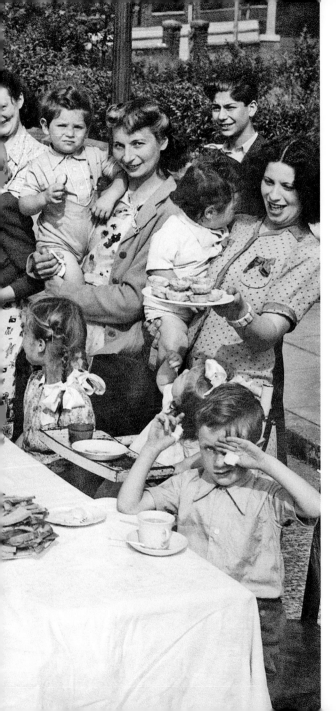

◄ A street party at Heaton Park, Manchester.

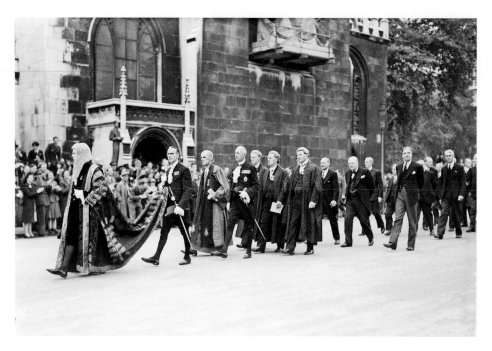

▲▶ Conservative Opposition Leader Winston Churchill is joined by Labour Prime
Minister Clement Attlee, Deputy Prime Minister Herbert Morrison, and Deputy
Conservative Leader Anthony Eden on the parade. During the war, Churchill led a
cross-party government as Prime Minister, wherein Attlee was Deputy Prime Minister,
Morrison was Home Secretary and Eden was Foreign Secretary.

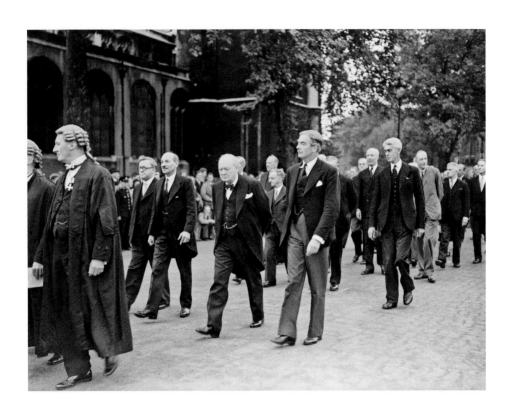

➤ Bristol's proclamation coach outside the Old Council House in Corn Street, where the lord mayor and citizens celebrate.

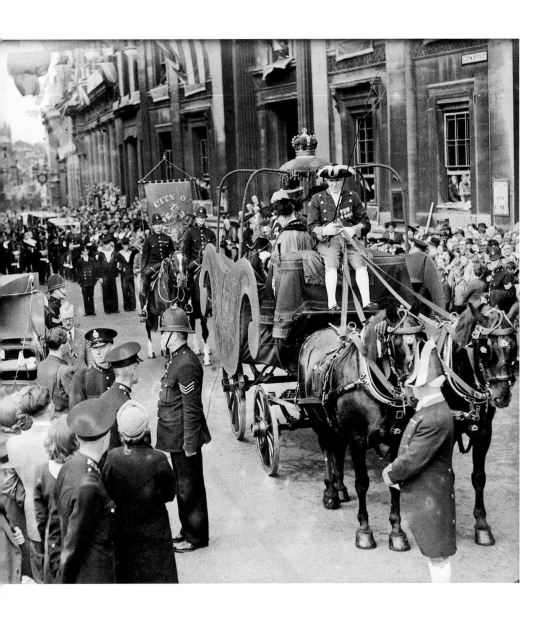

REBUILDING BRITAIN

We shape our buildings and afterwards our buildings shape us.

Winston Churchill
28 October 1943

Six years of war had left deep scars on Britain. The Blitz had killed 43,000 people and wounded nearly triple that, whilst almost 400,000 service members never came home. Thousands of buildings had been razed to the ground or made otherwise uninhabitable. Food was scarce, and years of austerity had taken its toll.

But the war was over now.

It was time for Britain to rise from the ashes. It was time to rebuild. Prefabricated homes, or 'prefabs' – houses that were mostly manufactured off-site and moved where needed – sprung up across the country to solve the housing crisis. Unexpectedly, rationing improved the health of the population, and the concept of a welfare state began to develop. Perhaps the most important part of this rebuilding, in a death-stricken and war-ravaged country, was the beginnings of the National Health Service.

➤ **April 1952:** A party at a bomb site on Anthony Street in London's East End.

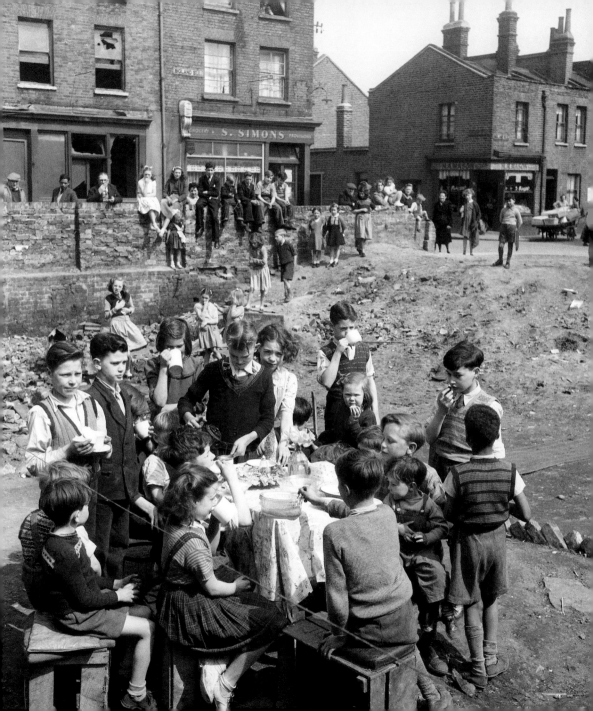

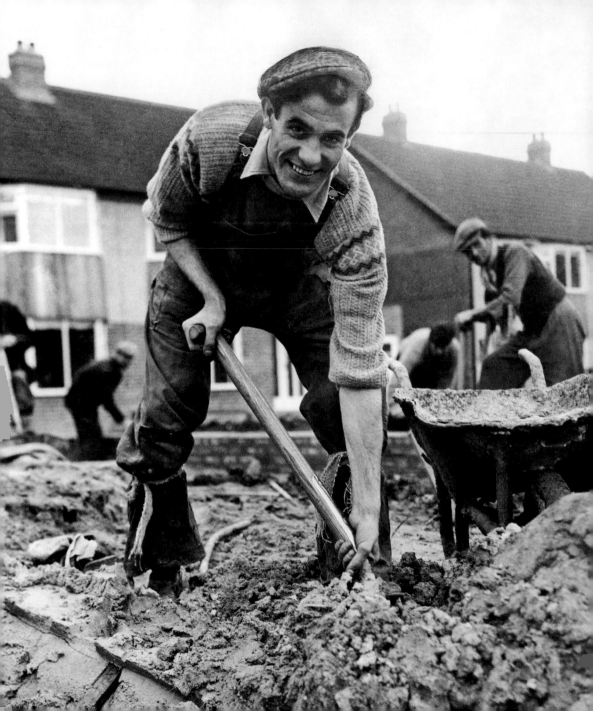

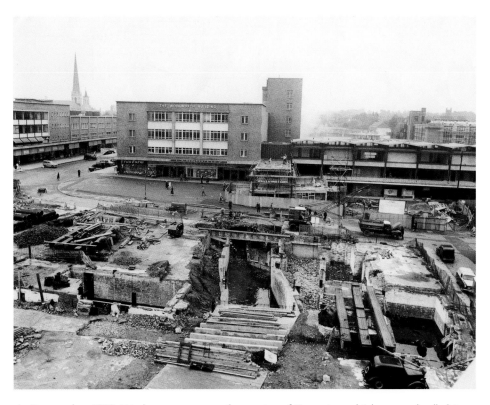

⌃ September 1958: Work progresses on the centre of Coventry, which was so badly hit during the Blitz that Joseph Goebbels coined the word *coventrieren* – to reduce to rubble.

◄ November 1958: 23-year-old Rikki Price pushing a barrowload of cement on a Sunderland building site.

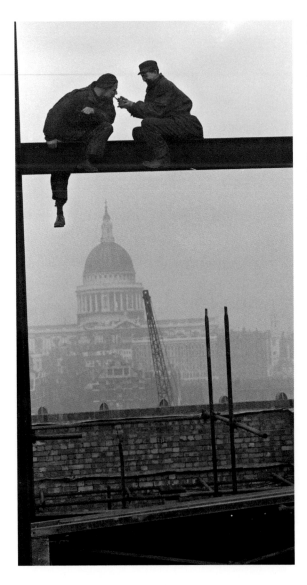

◄ **December 1951:** Way up on the high scaffolding of the new Bankside power station, which is towering over the tiny house in which Christopher Wren lived, the spidermen are building a huge chimney and station for the new power supply. In 2000 the building would be transformed into the Tate Modern – but here in 1951 two spidermen pause for a smoke break.

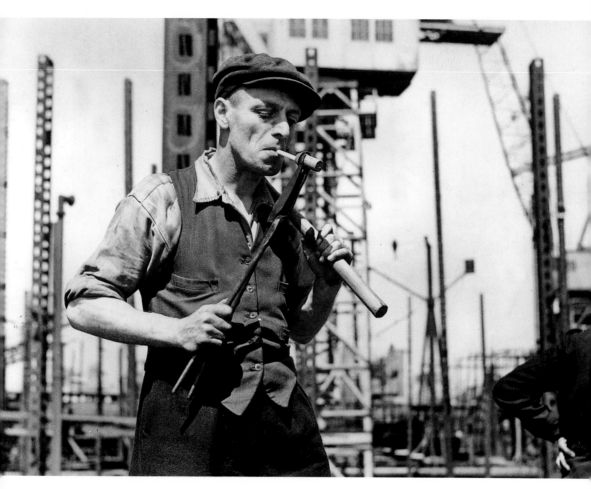

▲ **July 1948:** George Howard, a hand riveter, lights a cigarette from a white-hot rivet.

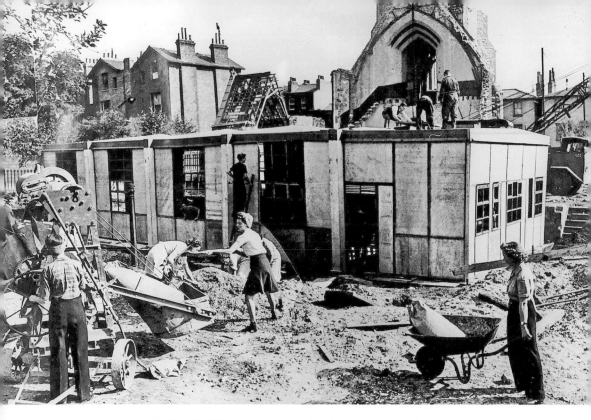

▲ **September 1945:** Rebuilding a Greenwich church that had been bombed.

➤ **July 1947:** Plymouth's squad of professional women navvies hard at work alongside the men, pulling down bombed premises to make way for rebuilding.

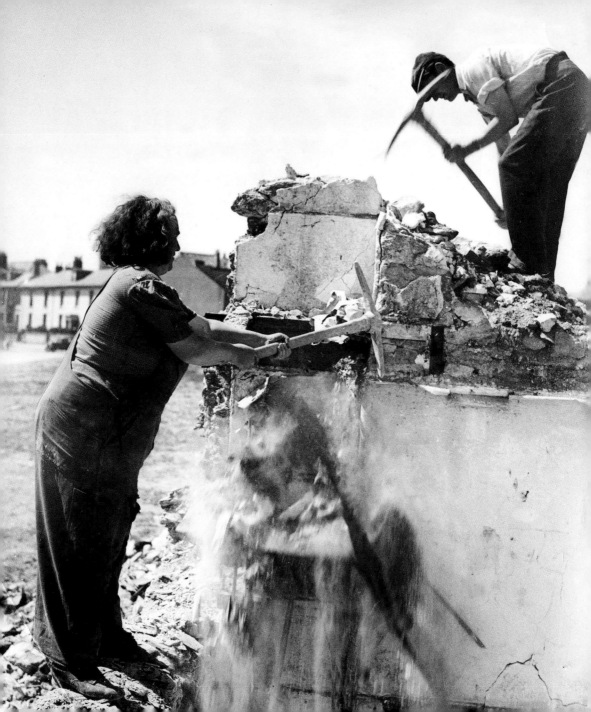

▲ **July 1948:** A day in the life of Shepherd Market, Mayfair, complete with bomb site.

➤ **October 1959:** A goods train makes its way across the tow bridge in the centre of Stourbridge whilst it is being reconstructed.

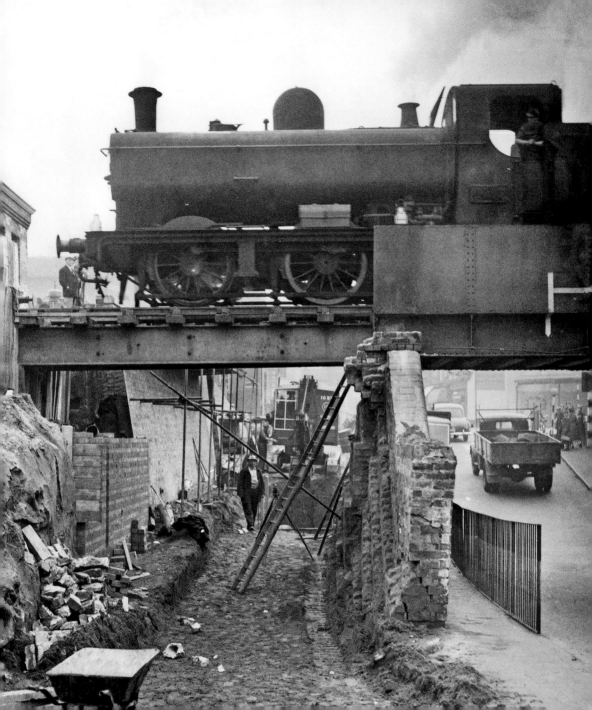

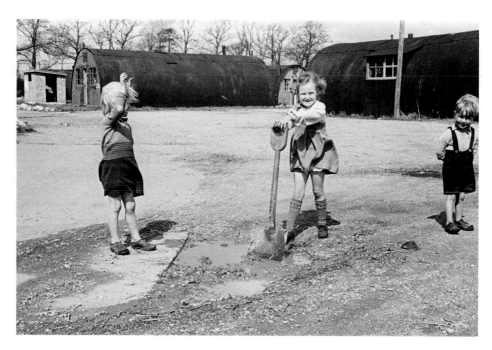

∧ **May 1947:** Three young children play in a deserted airfield.

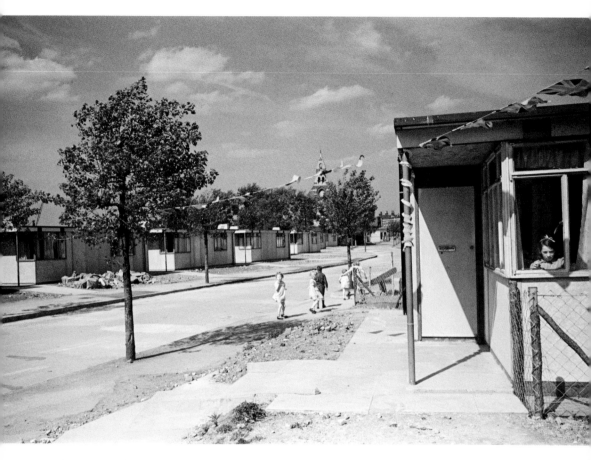

▲ **1946:** Families set up home in prefabricated houses in the Isle of Dogs.

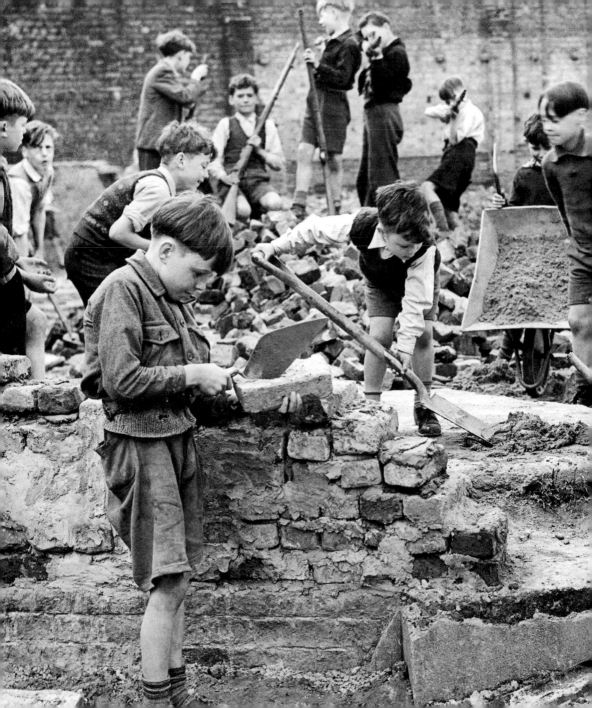

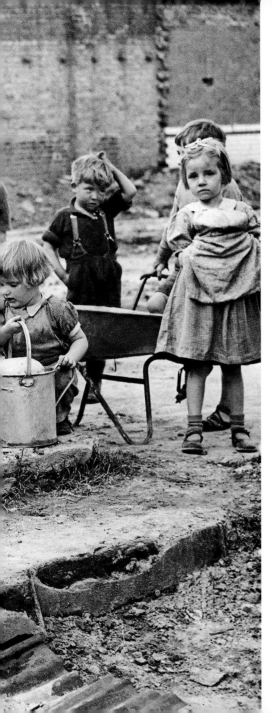

◄ **May 1948:** Children of Peckham are doing it 'just like the builders do' – a hive of industry is going on in the new children's playground opened on the Blitz site of St Luke's Church. With buckets of cement, sand from the play pit and bricks from the site, the work begins in earnest, but some prefer to play at soldiers with guns.

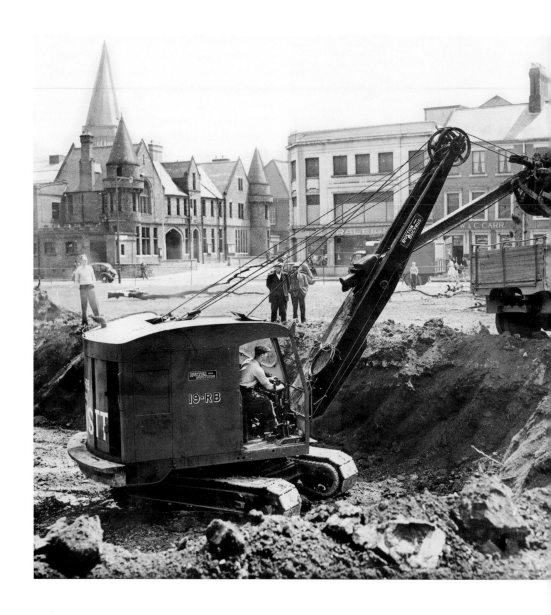

◄ **June 1958:** Construction of the new Newcastle Civic Centre; although it was commissioned pre-war, the actual building work didn't begin until 1956.

➤ **June 1958:** House building in Kirkby, Merseyside.

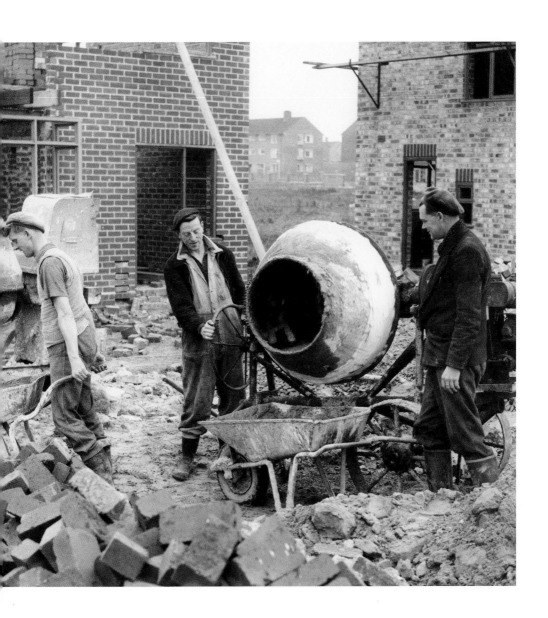

➤ **1949**: Devonport from the air, showing the extent of the war-time bombing.

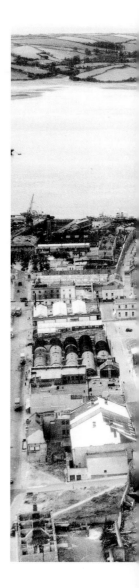

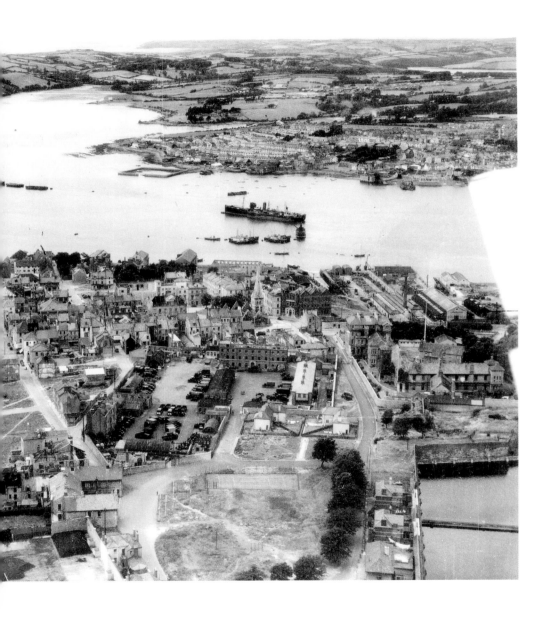

▲ **June 1946:** With many homes in Bristol in ruins following the Blitz, squatters were a familiar sight. Here, a family is living in an abandoned building in Somerset.

◄ **1971:** Temple Church in Bristol was bombed during the war but the famous leaning tower still survives.

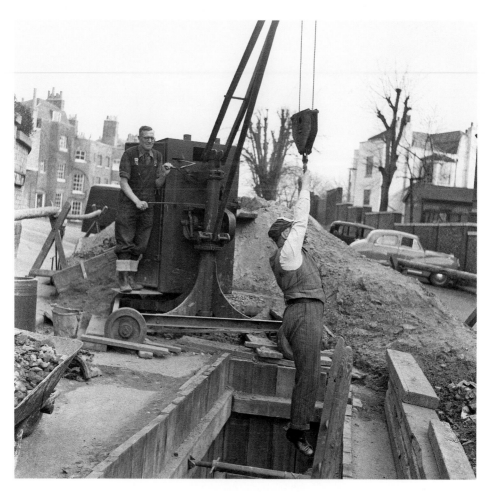

➤ **April 1954:** Up on the hills of Hampstead Green a sewer is being relined and the sewer foreman goes up and down the 25ft hole by holding on to the hook of a crane.

➤ **January 1954:** A scaffolder has no qualms with working at height, high above central Birmingham.

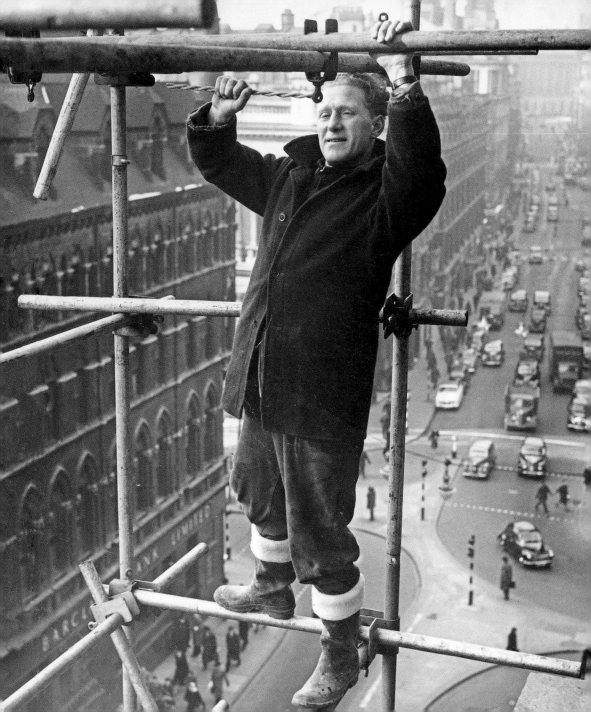

➤ **July 1959:** The new Rackhams building is being constructed at the corner of Corporation Street, Bull Street and Temple Row in Birmingham.

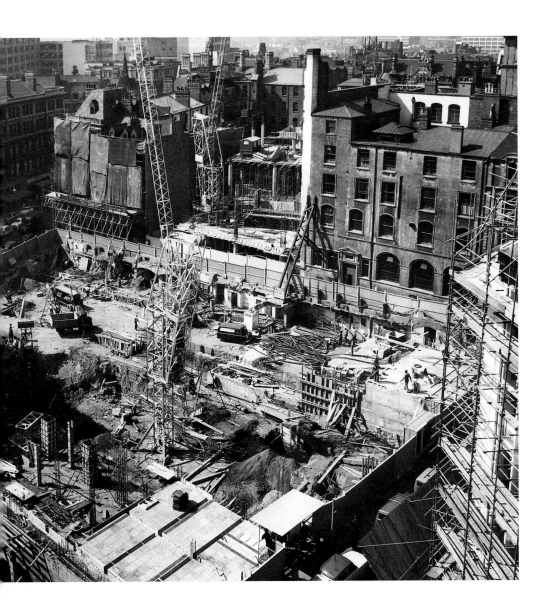

COMMEMORATION

There is great comfort in the thought that the years of darkness and danger in which the children of our country have grown up are over and, please God, forever.

George VI
Broadcast on VE Day

Until the First World War, war memorials were symbols of strength and victory, a celebration of military prowess. But the twentieth century would change this. Suddenly, war wasn't something that happened somewhere else – everyone had a parent, a child, a sibling who had been lost to war, and many of them didn't have graves. Tens of thousands of memorials were built across the country. Many still stand today.

It is, perhaps, because so much of the war happened on the Home Front, and so many civilians found themselves caught up in it, that the horrors of the Second World War have never left us. Although VE and VJ Day are mostly celebrations of the past, we still commemorate the Second World War; we still think of Dunkirk and Normandy; every schoolchild knows of the Blitz; and the sound of a Spitfire can still strike awe in our hearts. But perhaps the biggest memorial of all is the establishment of institutions like the United Nations, in a bid to stop wars.

This time, 'never again' might mean something.

➤ **May 1945:** Children commemorate VE Day by laying a wreath at the Cenotaph in London.

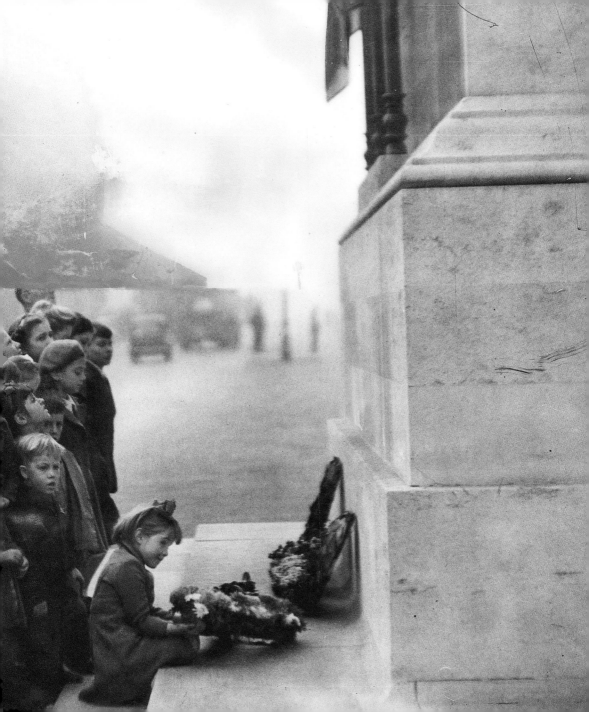

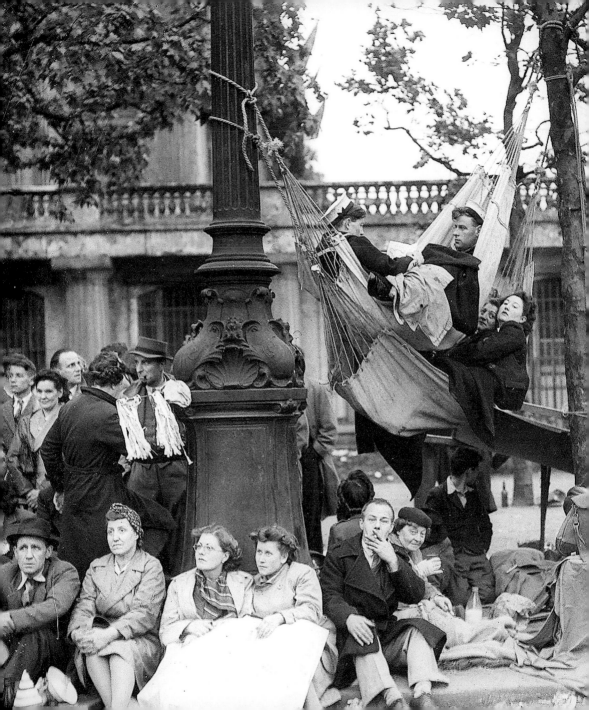

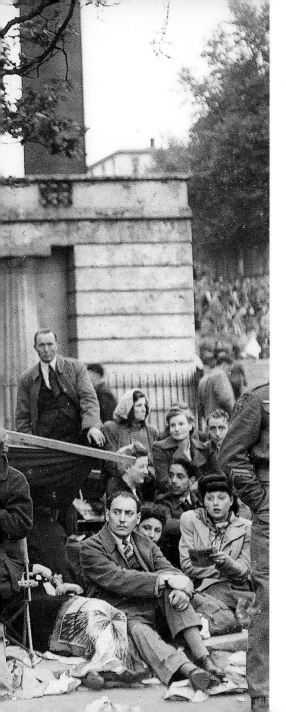

◄ **June 1946:** Victory Day scenes a year on.

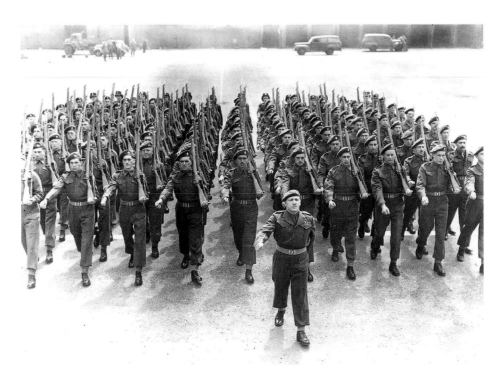

▲ **June 1946**: Canadian troops practising for the Victory Parade in London.

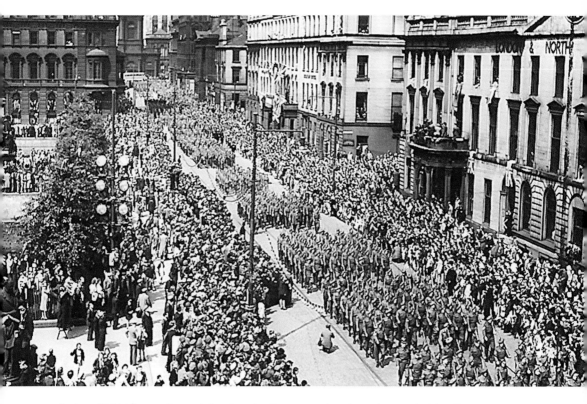

▲ **June 1946:** Victory Day celebrations in Glasgow, going along the north side of George Square.

➤ **May 1985:** Nazi Germany survivor Roger Chapuis, in his concentration camp stripes, joins in Prudhoe's VE Day service.

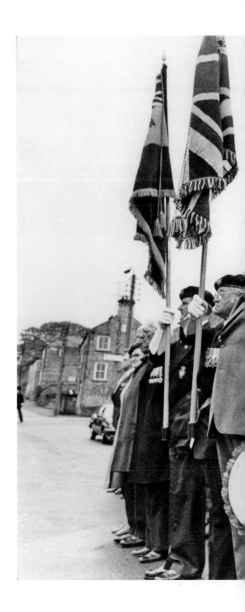

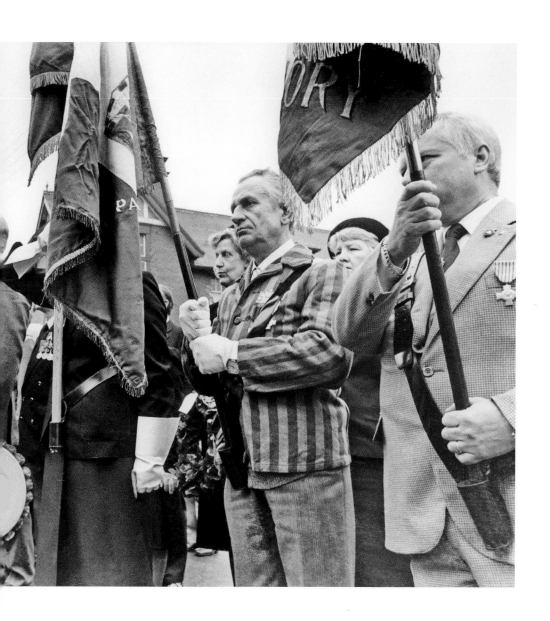

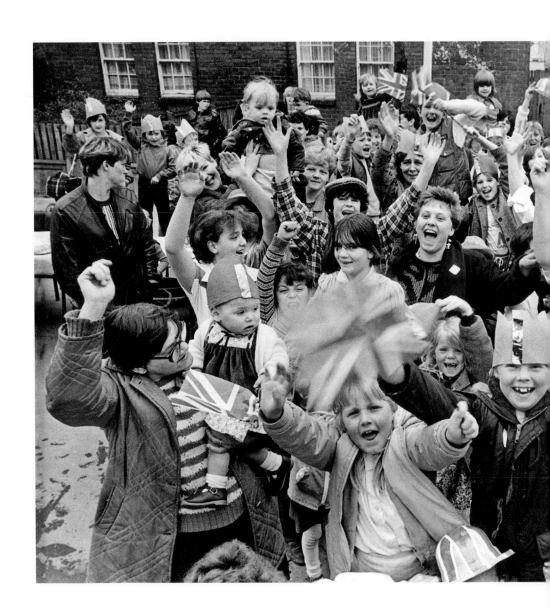

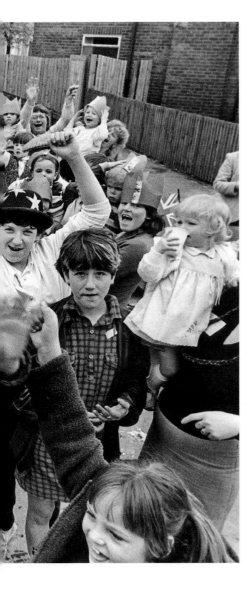

◄ **May 1985:** Cowgate Credit Union organised these celebrations in and around Greenhill View to commemorate the fortieth anniversary of VE Day.

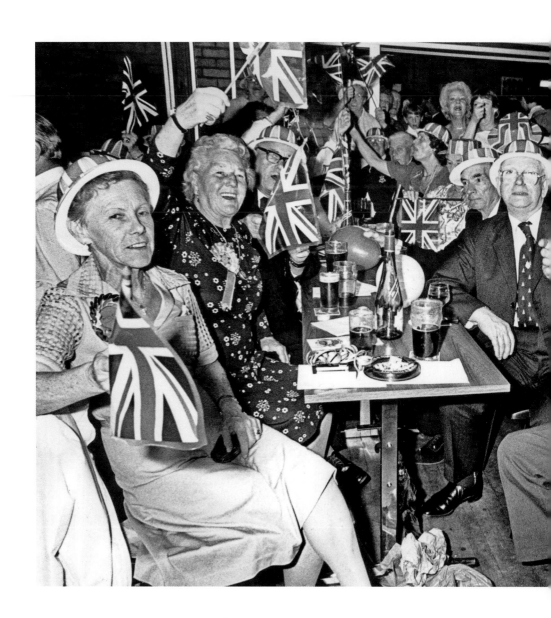

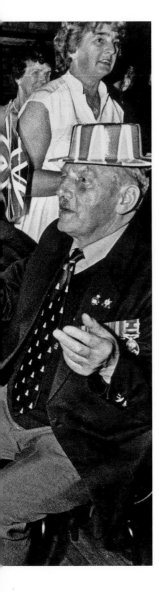

◀ **August 1985:** The fortieth anniversary celebrations of VJ Day in Coventry.

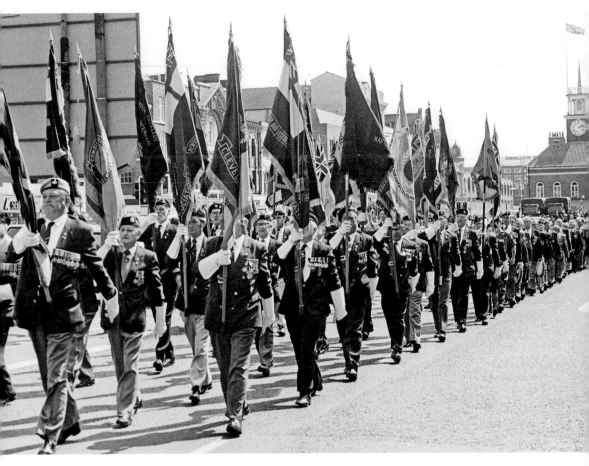

▲ **May 1987:** Past and present servicemen march through Stockton High Street.

➤ **May 1995:** A veteran at the fiftieth anniversary VE Day service.

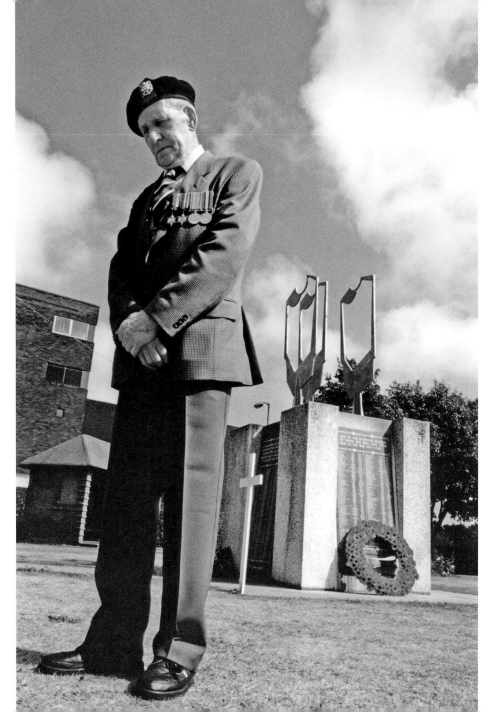

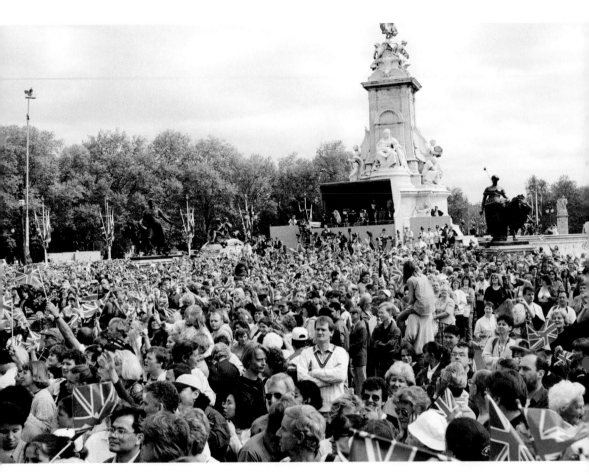

▲ **May 1995:** Crowds gather outside Buckingham Palace to celebrate the fiftieth anniversary of VE Day.

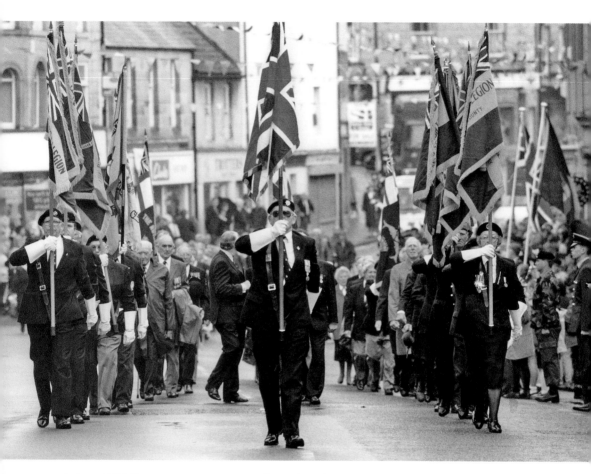

∧ June 1995: The commemorative parade in Alnwick.

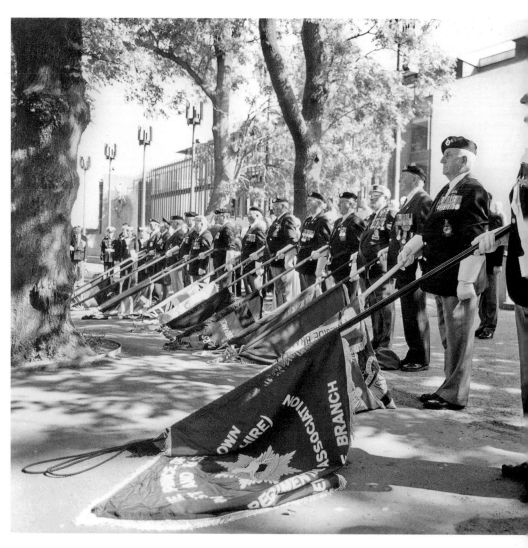

▲ **August 1995:** A VJ Day remembrance service at Newcastle Civic Centre.

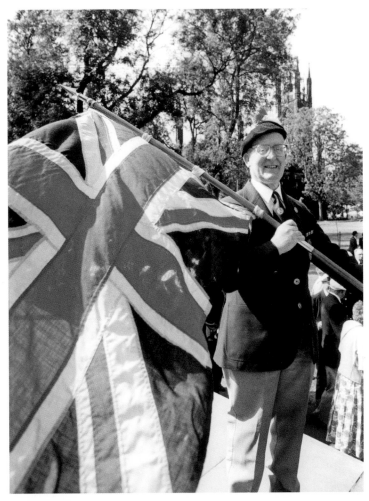

▲ **August 1995:** Ex-prisoner of war Fusilier Tommy Cragie, 78, of Newcastle, with a Union Flag that was hidden from the Japanese in one of the camps.

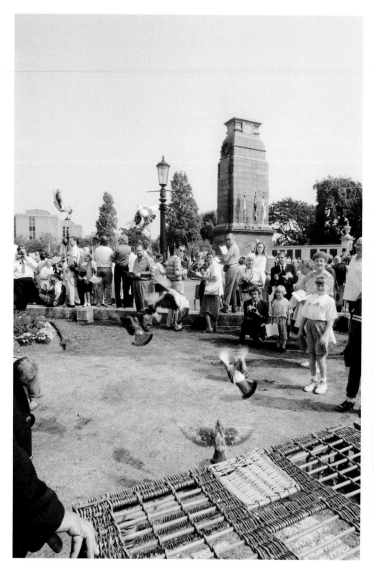
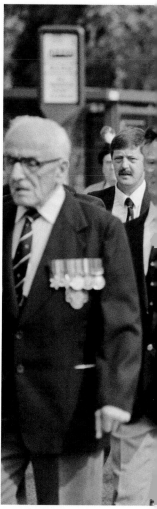

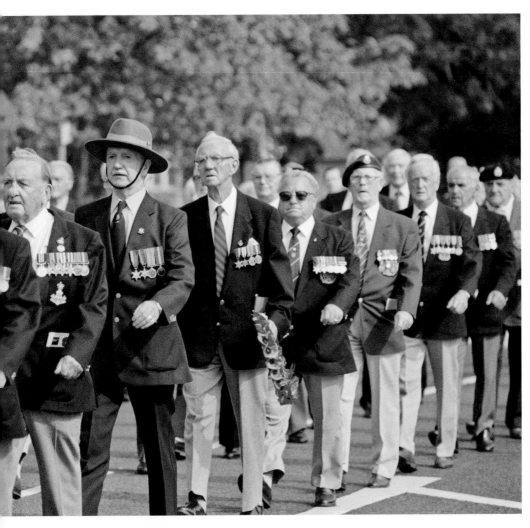

◄▲ **August 1995:** The VJ Day Fiftieth Anniversary Parade to the Cenotaph, Middlesbrough, where pigeons were released.

➤ **August 1995:** Servicemen and women in Middlesbrough's parade.

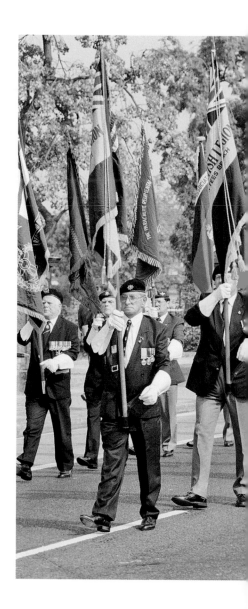

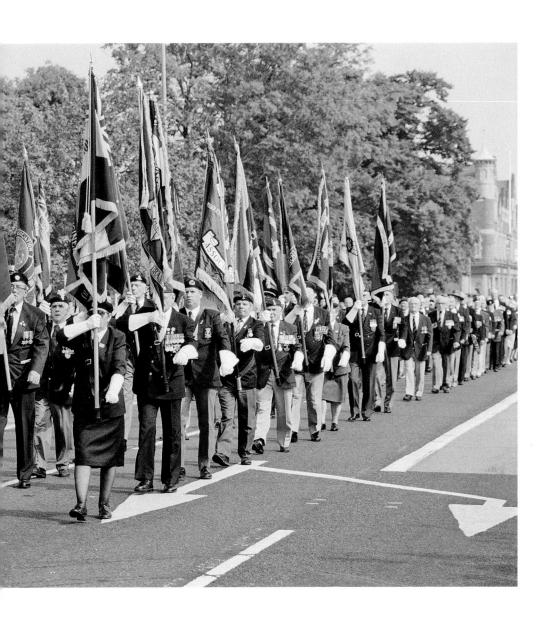

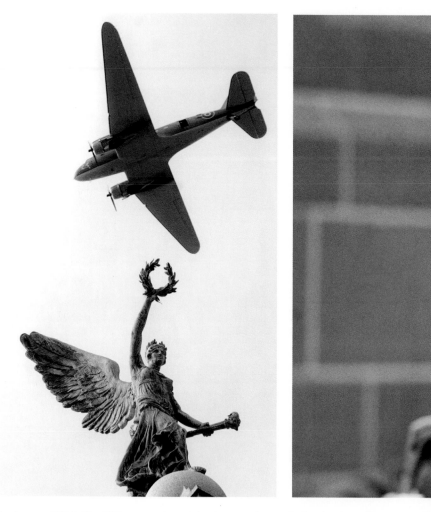

▲ **August 2000:** The VJ Day parade at Mowbray Park, Sunderland. A Douglas DC-3 Dakota plane makes a flyover.

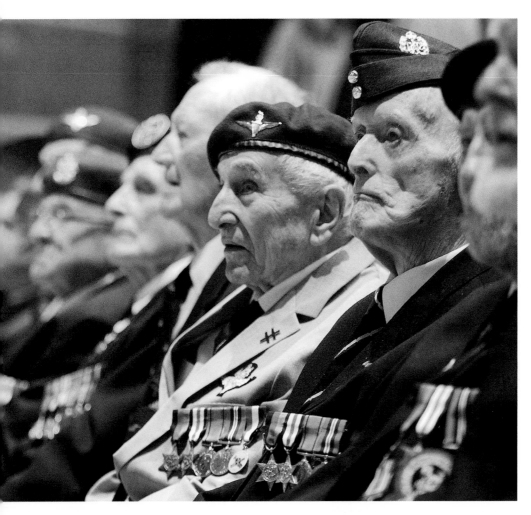

▲ **May 2015:** The dedication of the Heroes' Path at Liverpool Anglican Cathedral on the seventieth anniversary of VE Day.

You may also enjoy …

978 0 7509 8565 9